STANDARD BOOK OF

PRADA

1913

Chloé Kamali-Worth

STANDARD BOOK OF

PRADA

1913

CHLOE KAMALI-WORTH

UNOFFICIAL AND UNAUTHORIZED

Copyright © 2024
All rights reserved. No part of this publication may be reproduced, distributed or transmitted in any form or by any means, including photocopying, recording, or other electronic or mechanical methods, without the prior written permission of the publisher, except in the case of brief quotations embodied in reviews and certain other non-commercial uses permitted by copyright law. Any references to historical events, real people or real places may be actual or used fictitiously to respect anonymity. Names, characters and places may be the product of the author's imagination.

Mario Prada: The Visionary Behind the Iconic Luxury Brand

In 1913, Mario Prada laid the foundation stone for a fashion empire that would become synonymous with luxury, innovation and avant-garde design: Prada. Founded in Milan, Italy, Prada began as a leather goods boutique, offering exquisite leather products crafted with unrivaled craftsmanship. This article explores the legacy of Mario Prada, the founder of this iconic brand, and his lasting impact on the luxury fashion industry.

A Modest Beginning with a Grand Vision

Mario Prada, with his brother Martino, opened the original boutique under the name "Fratelli Prada" (Prada Brothers) in Milan. This store offered luxury leather travel items, handbags, boxes and accessories that attracted an elite clientele, including European royalty. What set Mario Prada apart in the fashion landscape of the time was his insistence on quality and the use of exotic materials, such as walrus leather, to create luxurious and durable items.

An Innovative Spirit in a Changing World

Mario Prada was known for his conservative approach to business, but he was also a visionary who understood the importance of innovation. At a time when fashion and luxury were dominated by centuries-old traditions, he sought to introduce innovative materials and manufacturing techniques. This allowed Prada to stand out in a competitive market and lay the foundations for a brand that would always be looking for innovation.

The codes of luxury
Prada

Prada, as an iconic luxury brand, embodies a set of distinctive codes that define its identity and underline its status in the world of haute couture and luxury leather goods. These codes, or stylistic signatures, are not only symbols of prestige and exclusivity, but also testimonies of innovation, craftsmanship and commitment to sustainability. Here are the main luxury codes that characterize Prada:

1.Sophisticated Minimalism
Prada is renowned for its minimalist approach, which is distinguished by a sophisticated simplicity. Clean designs, clear lines and structured silhouettes are at the heart of its collections, offering a timeless elegance that transcends fleeting fashion trends.

2.Material Innovation
Innovation in the use of materials is a pillar of Prada. The brand pioneered the use of nylon, transforming this humble material into a symbol of modern luxury. Technical fabrics, often used in unexpected ways, are becoming signature design elements that reflect a fusion of functionality and high fashion aesthetics.

3.Artisanal know-how
Prada's luxury lies in its commitment to excellent craftsmanship. Each product is the result of meticulous craftsmanship, where traditional techniques meet innovation. This respect for craftsmanship is evident in the unrivaled quality of its leathers, precise stitching and delicate finishes.

4. Intellectual Aesthetics
Under the creative direction of Miuccia Prada, the brand adopted an intellectual aesthetic, often incorporating elements of counterculture, art and politics into its designs. This thoughtful approach challenges fashion conventions and encourages reflection on contemporary culture and personal identity through the lens of fashion.

5. Distinctive Visual Identity
The Prada logo, with its minimalist and elegant design, is immediately recognizable and symbolizes luxury and quality. Prada stores themselves, often designed by renowned architects, reflect the visual identity and values of the brand, creating spaces that combine luxury, art and design.

01

Prada's luxury codes reflect harmony:
between tradition and innovation, between aesthetics and functionality. These principles guide the brand in its constant quest for excellence, allowing it to remain at the forefront of luxury fashion while respecting its heritage.

02

Introduction du Nylon:
In the 1980s, Prada revolutionized luxury fashion by introducing nylon, a material considered unconventional at the time, into its collections, notably with the launch of the black nylon backpack which became iconic.

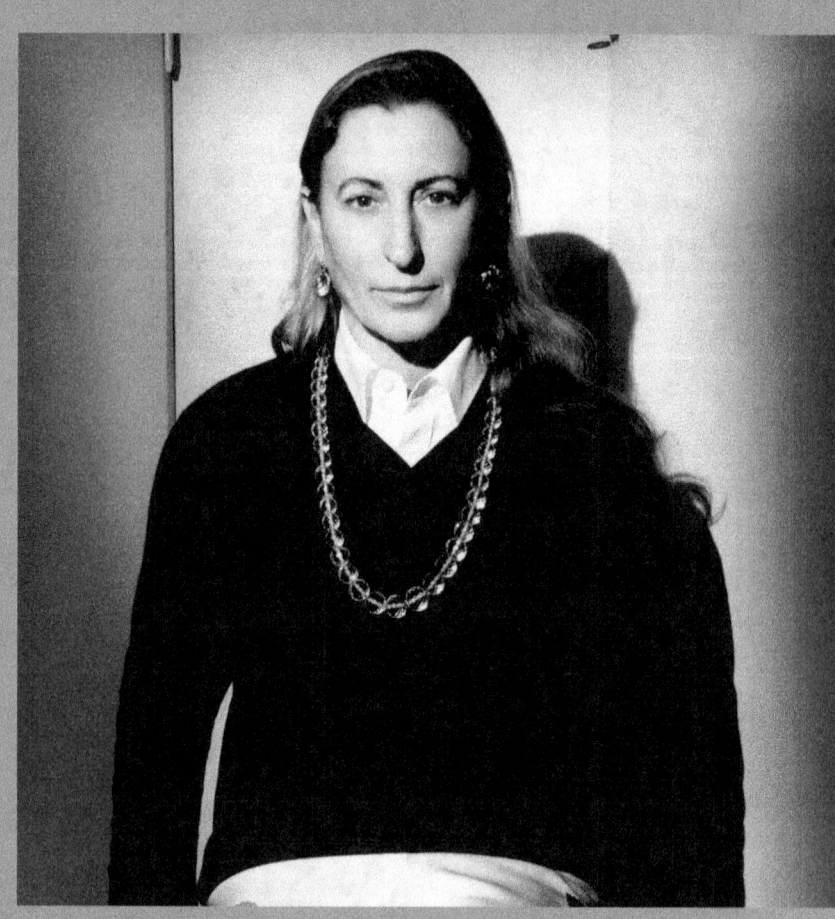

03

Creative Direction of Miuccia Prada:
Miuccia Prada, granddaughter of Mario Prada, took over as creative director of the company in 1978, transforming the brand into a globally recognized ready-to-wear fashion giant.

04

Miu Miu Line Launched: In 1993, Miuccia Prada launched Miu Miu, a more affordable, youth-oriented fashion line named after her nickname.

The launch of Miu Miu:

in 1993 by Miuccia Prada represents a key milestone in the expansion of the Prada group, illustrating the house's strategic vision of diversifying its offering while targeting a new market segment. Miu Miu, taking its name from Miuccia Prada's nickname, embodies a distinct identity within the Prada universe, offering a more affordable and decidedly youthful alternative to the brand's main line.

Philosophy and Positioning:

Miu Miu is distinguished by a more playful and provocative approach to fashion, in contrast to the sophisticated minimalism and timeless elegance of Prada. The brand aims to capture the spirit of younger generations through bold designs, eclectic patterns and bright colors, reflecting a rebellious and avant-garde attitude.

Aesthetics and Collections:

Miu Miu's aesthetic revolves around experimentation, playing on style contrasts, unexpected layering and unique details. The collections combine vintage influences and contemporary trends, offering pieces that are both feminine and provocative. Accessories, particularly handbags and shoes, have become iconic elements of the brand, coveted for their originality and attention to detail.

Reception and Impact:
Since its launch, Miu Miu has quickly gained popularity, attracting a young and trendy clientele. The brand has established a strong presence in the fashion world, with highly anticipated shows during Fashion Weeks in Paris and elsewhere. Miu Miu's advertising campaigns, often shot by renowned photographers, contribute to its bold and innovative brand image.

Commitment to Art and Cinema:
Miu Miu has also distinguished itself by its commitment to the field of art and cinema. The brand's "Women's Tales" project, a series of short films directed by talented female filmmakers, demonstrates its commitment to promoting women's voices in the film industry.

Conclusion:
The launch of Miu Miu by Miuccia Prada has not only enabled the Prada Group to reach a younger and wider audience, but has also enriched the fashion landscape with a brand that celebrates individuality, experimentation and young spirit. Miu Miu continues to be an influential force in contemporary fashion, testament to Miuccia Prada's ability to innovate and redefine the boundaries of elegance and style.

TRENDY INSPIRATIONAL MIUMIU OF THE DAY

CHOOSE A MIUMIU STYLISH LOOK

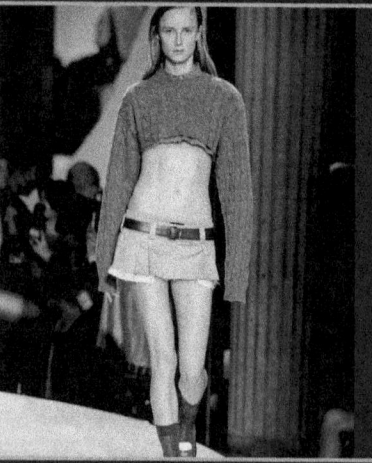

every day

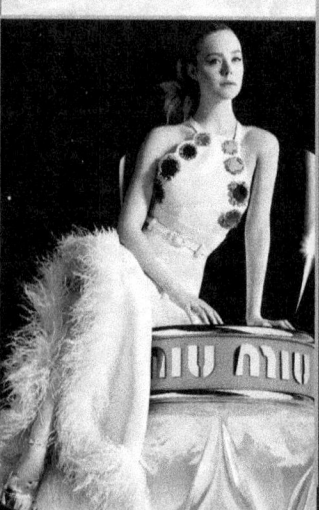

Miu Miu's commitment to art and film, particularly through its innovative "Women's Tales" project, perfectly illustrates how the brand transcends traditional fashion boundaries to embrace and promote culture and feminine expression. Launched in 2011, "Women's Tales" is a bold initiative that provides a platform for female filmmakers from around the world to create short films that explore the lives, experiences and perspectives of women through the lens of Miu Miu fashion.

Objectives and Vision

The "Women's Tales" project is part of Miu Miu's broader desire to support the creative expression of women and to highlight female talents in fields traditionally dominated by men, such as cinema. This film series aims to celebrate the diversity and richness of female voices by giving female directors complete creative freedom to explore themes close to their hearts, while integrating Miu Miu aesthetics and products in subtle and meaningful ways.

Directors and Works

Since its launch, "Women's Tales" has featured works by acclaimed and emerging female directors, such as Agnès Varda, Ava DuVernay, Miranda July, and Chloë Sevigny, among others. Each short film is unique, ranging from introspective narratives to bold visual explorations, reflecting the diversity of female experiences and the richness of female storytelling.

05

Expansion into Ready-to-Wear: Under Miuccia's leadership, Prada expanded its offerings into ready-to-wear in the 1980s, introducing its first womenswear collection in 1988 and menswear in 1995.

TIMELESS ELEGANCE: THE PRAIRIE ODE

In the setting of a world woven of dreams and reality,
Prada stands, in majesty, queen of the city.
Its silhouettes dance, between shadows and light,
Whispering secrets of elegance, sweet prayer.

Under the Milanese sky, where history meets style, Prada weaves its myth, eternal and fragile.
Each piece, a promise of innovation, An ode to beauty, to passion.

Bags, like works, carry stories, Travelers' dreams, whispers in the dark.
Shoes, light steps on the path of daring, Guide free souls, in a passing world.

Miuccia, guardian of the temple, unparalleled visionary,
Mixes art and fashion, under the same sun.
With Bertelli, she is paving a path for the future, where fashion is a language, for those who know how to read it.

In the workshop, hands are busy, with love and devotion, creating miracles of fabric, fruits of their imagination.
Prada is the story of a heritage, a name, A family, an empire, built on passion.

The future is coming, still full of promises, Prada moves forward, proud, opening each door.
In the poetry of fashion, his verse is immortal, Prada, shooting star, in the eternal sky.

PRADA | 15

Commitment to Sustainability: Prada is committed to several sustainability initiatives, including the Re-Nylon project, aiming to replace all of its nylon with recycled nylon by 2021.

The Prada Foundation: In 1993, Miuccia Prada and Patrizio Bertelli created the Prada Foundation, a space dedicated to the exhibition of contemporary art, reflecting the brand's commitment to culture and art.

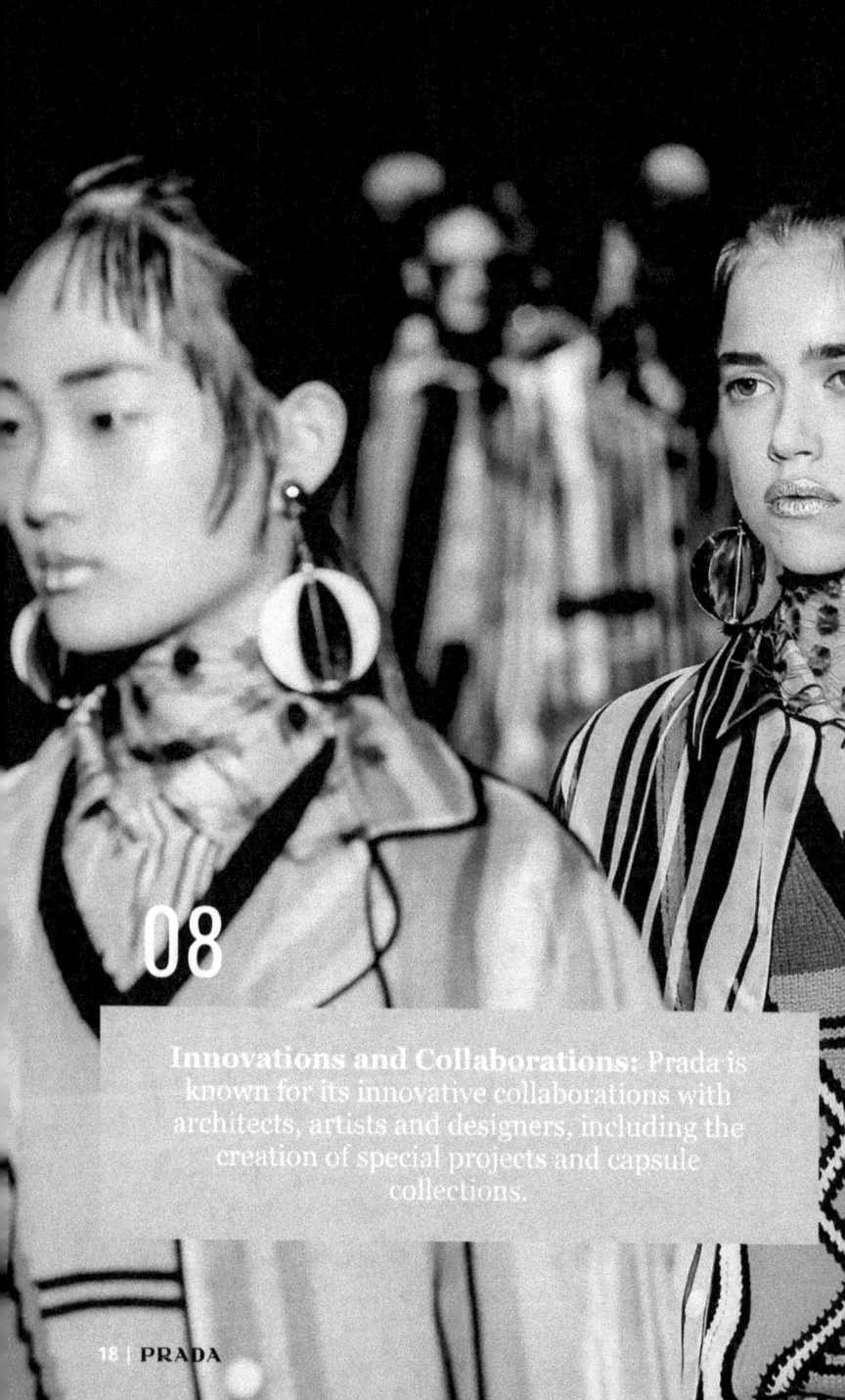

08

Innovations and Collaborations: Prada is known for its innovative collaborations with architects, artists and designers, including the creation of special projects and capsule collections.

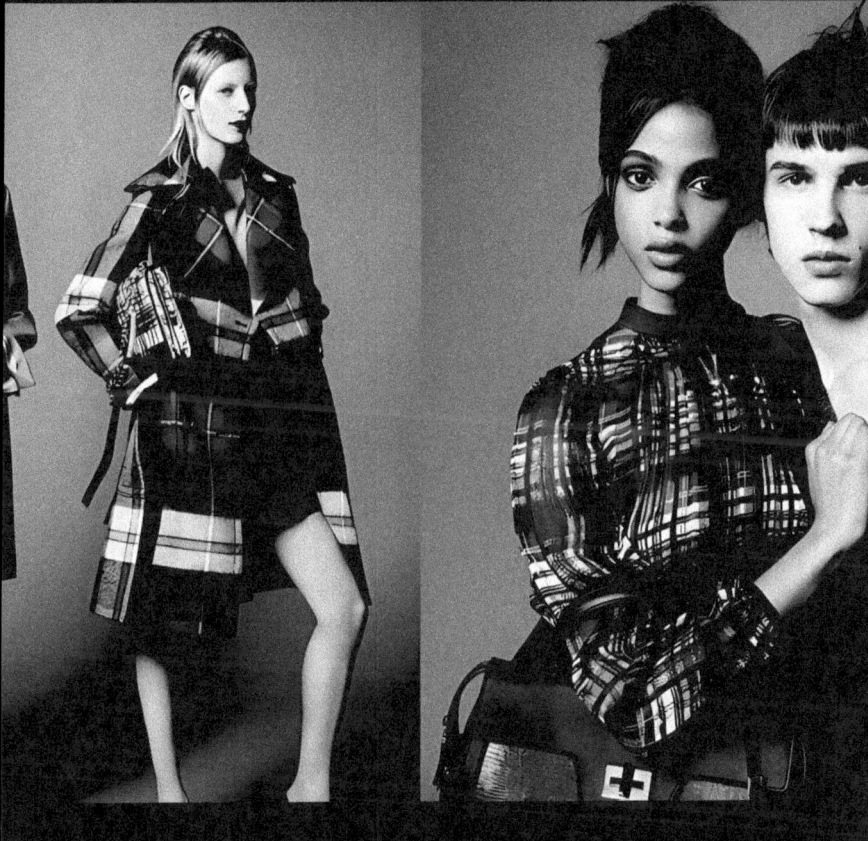

09

Digital Initiatives: Prada was one of the first luxury brands to embrace e-commerce and social media, establishing a strong and interactive online presence that reflects its innovative brand image.

This Thursday, February 23, the Italian fashion house Prada presented its collection for fall-winter 2023-2024.

In 54 silhouettes imagined by Miuccia Prada & Raf Simons,
the luxury brand continued to prove to what extent sartorial simplicity could be a symbol of beauty. When the covid-21 pandemic swept across the globe, the fashion industry knew that it was time to rethink. And if we are far from being able to say that things have changed drastically, we still feel that certain designers continue to question the role of clothing in our current societies. Miuccia Prada and Raf Simons, two-headed hydra of the house of Prada, are among those who continue to push for a redefinition of modern fashion. "What mainly matters to me now is to give importance to what is modest, to value modest jobs, simple jobs, and not just extreme beauty or glamour," Miuccia Prada is said to have confided backstage at the Prada fall-winter 2023-2024 fashion show according to Marie Claire1.

We blur the barriers,
between everyday clothing and occasional wear from the first look, namely a gray knit sweater slipped over a white tube skirt enhanced by embroidered tulle. Further, the military wardrobe is given a twist with silk materials, the business suit is redesigned in a red textured leather version, the nurse's blouse becomes a long tunic with a long train that exaggerates movement... A sincere, simple fashion but never without poetry. In short, beauty according to Prada.

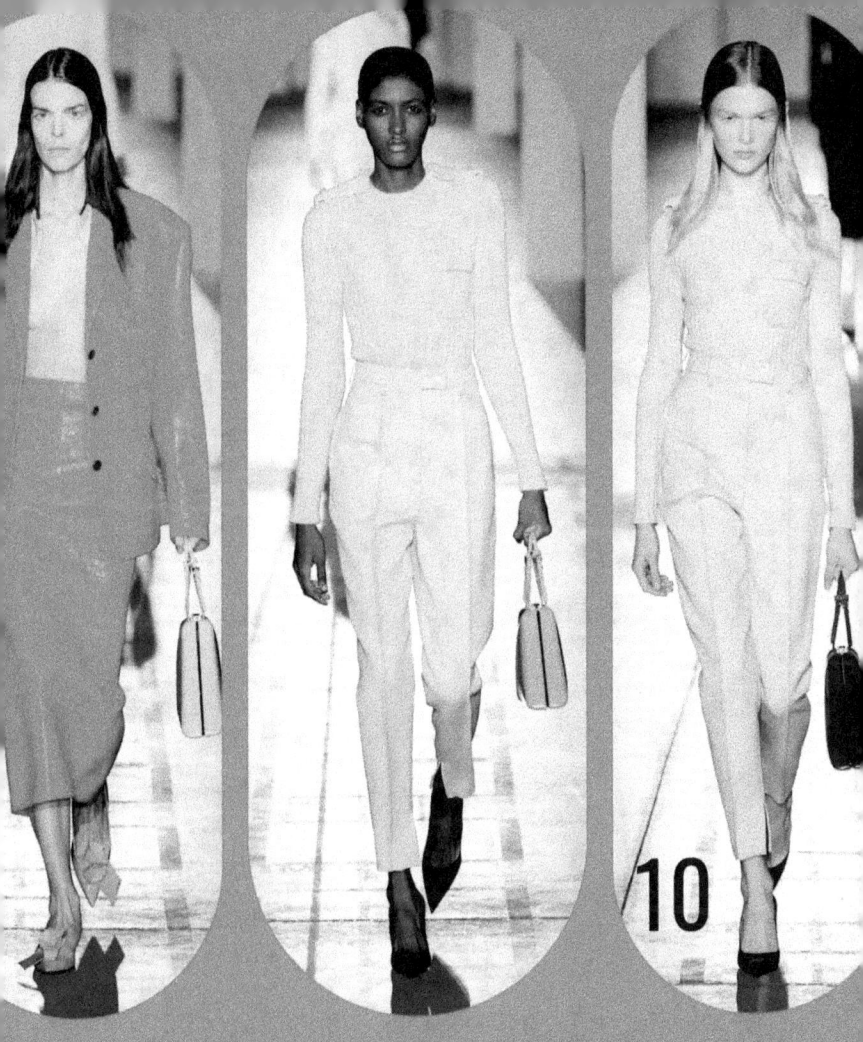

Innovation and Sustainability: Prada has continued to emphasize material innovation and sustainability in its recent collections. For Fall-Winter 2023-2024, it is likely that the brand will have integrated recycled or eco-responsible materials, following its commitment to more sustainable practices, as evidenced by their Re-Nylon project.

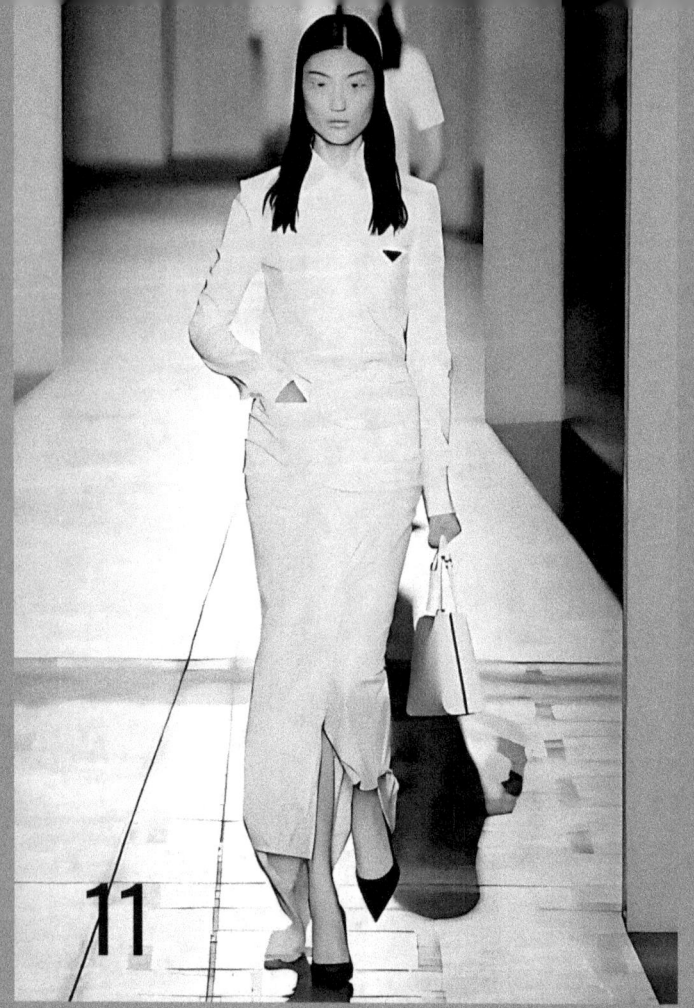

Fusion of Traditional and Modern: Prada is renowned for its skill in fusing traditional design elements with modern, fashion-forward touches. This collection could have presented a range of pieces mixing classic cuts and stylistic innovations, highlighting the brand's intellectual approach to fashion.

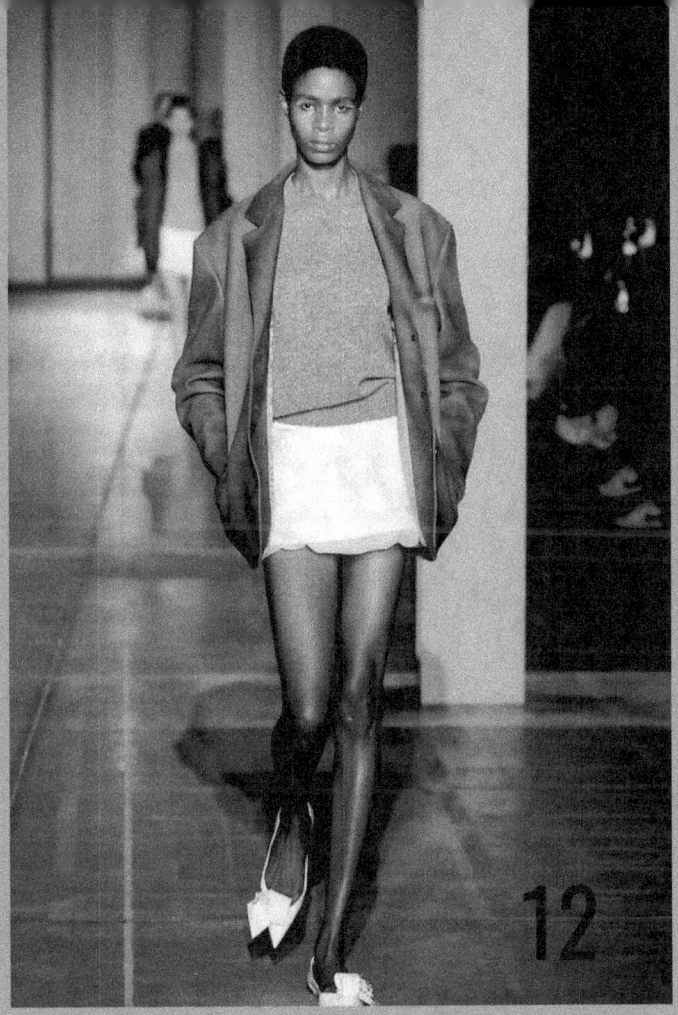

Rich Visual Aesthetic: Under the creative direction of Miuccia Prada and Raf Simons, the brand has often explored complex themes throughout its collections, using fashion as a means to express broader ideas about society, culture and identify. For Fall-Winter 2023-2024, the collection could have highlighted a rich visual aesthetic, with a bold color palette, innovative prints and particular attention to details and textures.

13

International Expansion: In the 1990s, Prada underwent rapid international expansion, opening boutiques in major cities around the world, including New York, Paris, and Tokyo, marking its global presence in luxury.

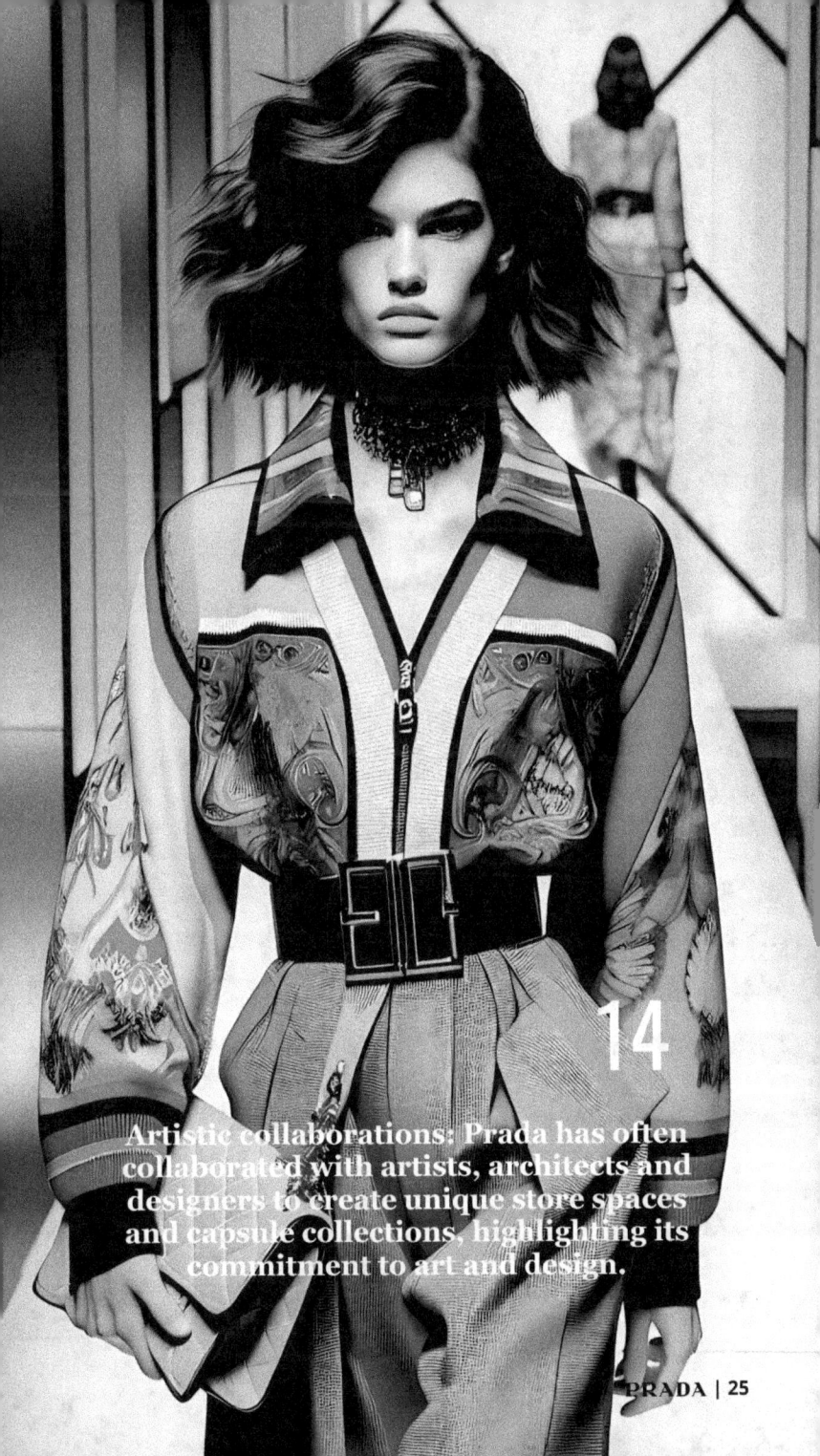

14

Artistic collaborations: Prada has often collaborated with artists, architects and designers to create unique store spaces and capsule collections, highlighting its commitment to art and design.

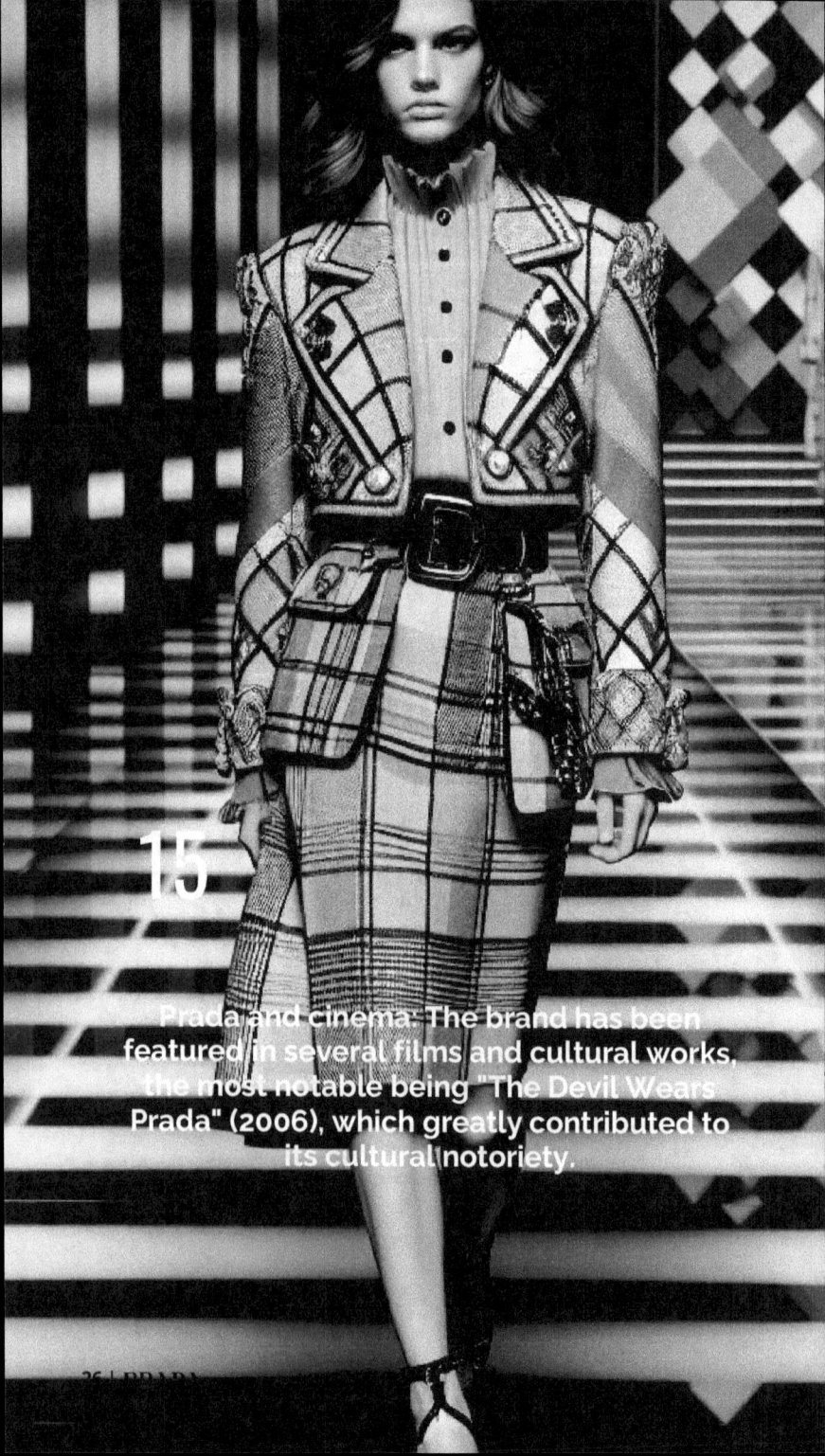

15

Prada and cinema: The brand has been featured in several films and cultural works, the most notable being "The Devil Wears Prada" (2006), which greatly contributed to its cultural notoriety.

ICONIC　　　　　　　　　　　　　　　　　　　　　　　　DESIGN

PREVIEW

[ACCESSORY]

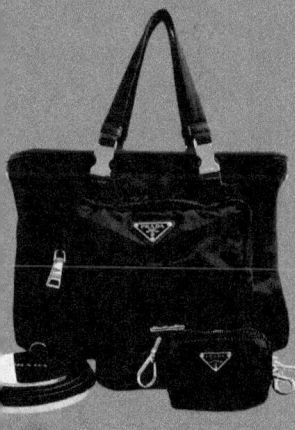
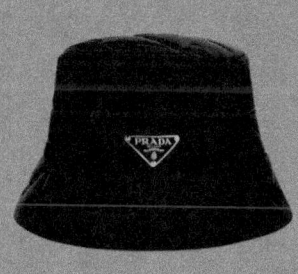

Iconic Accessories from Prada: A Touch of Everyday Luxury

Prada, synonymous with elegance and avant-garde, transcends the world of fashion with its collection of essential accessories. Each piece, whether an elegant bucket hat, an iconic bag or a designer water bottle, embodies the innovative spirit and attention to detail that characterize the Italian house. These accessories are not simple complements; they are at the heart of Prada's identity, reflecting a perfect blend of functionality and style.

TRENDS
PROJECTS
COLLECTIONS
FACES DESIGNERS
AWARDS

ITALY 🌐

PRADA.COM

Prada bags are more than just a way to carry your belongings. these are iconic models like the Prada Galleria with the reinvented nylon bag, each bag tells a story of tradition, innovation and uncompromising craftsmanship. These timeless pieces are the symbol of understated luxury, offering their wearers effortless elegance and instant distinction.

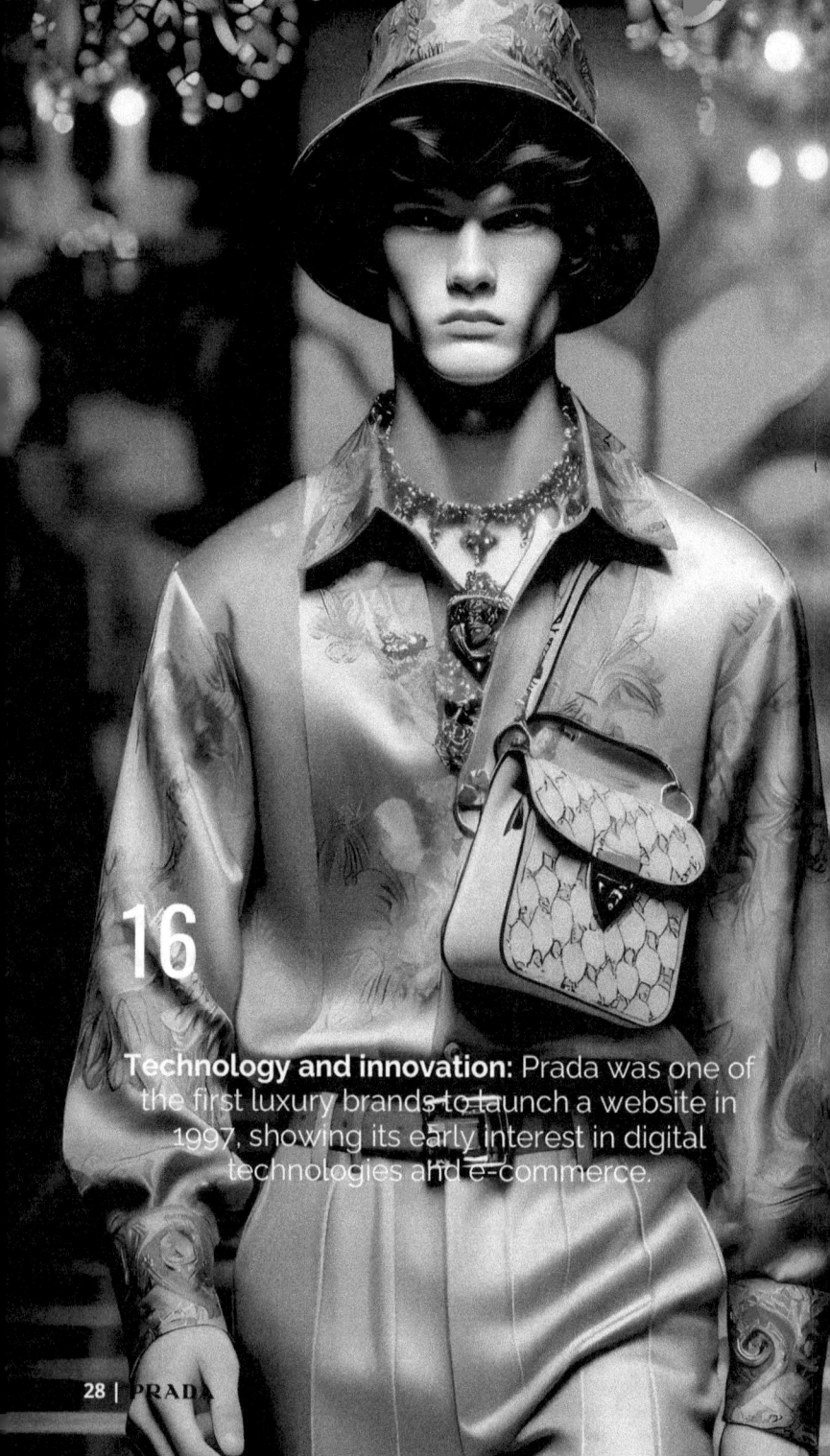

16

Technology and innovation: Prada was one of the first luxury brands to launch a website in 1997, showing its early interest in digital technologies and e-commerce.

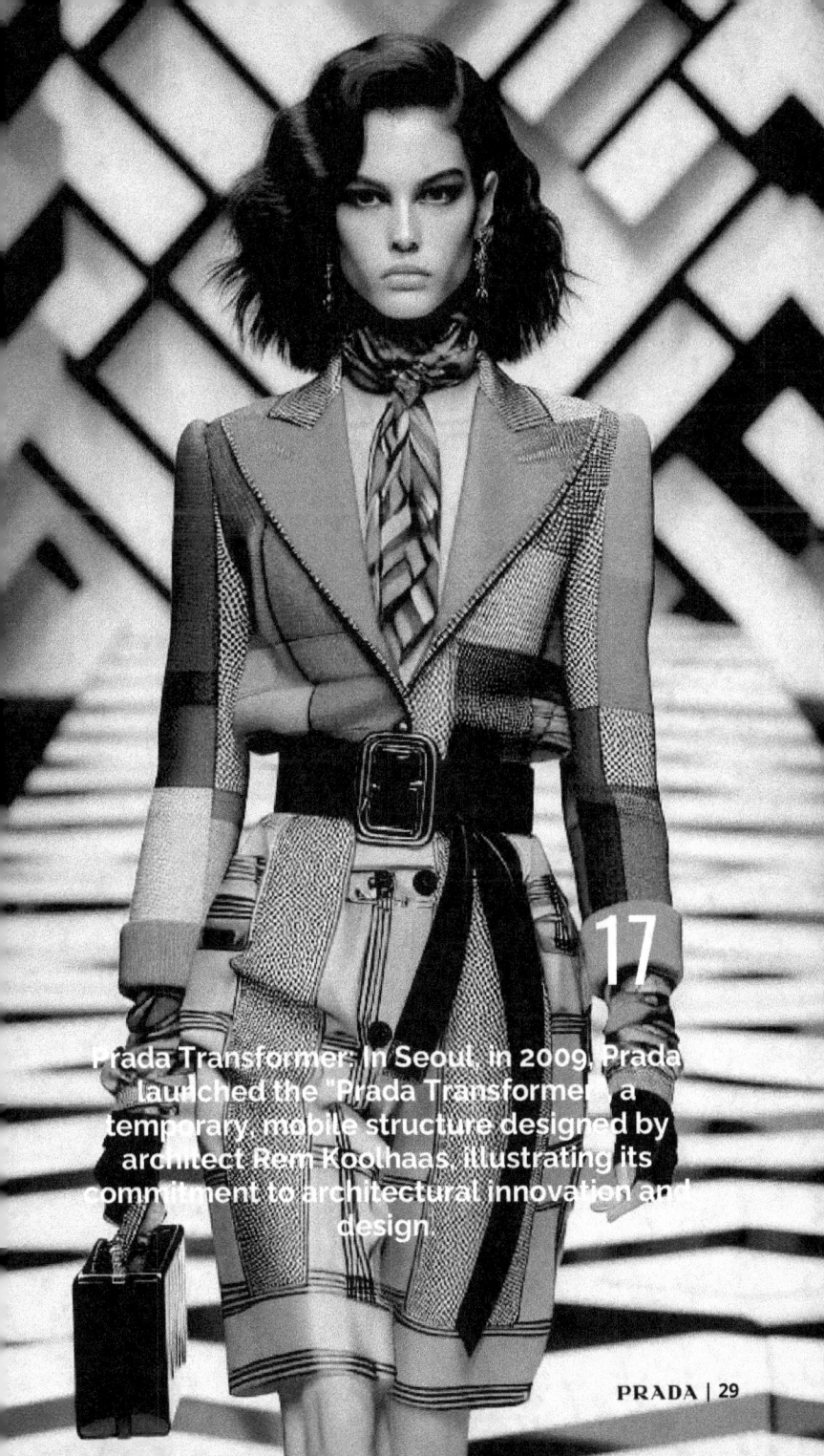

17

Prada Transformer: In Seoul, in 2009, Prada launched the "Prada Transformer," a temporary, mobile structure designed by architect Rem Koolhaas, illustrating its commitment to architectural innovation and design.

18

Social and cultural commitment: Beyond fashion, Prada invests in social and cultural initiatives, notably through the Prada Foundation, which organizes art exhibitions, research projects and conferences.

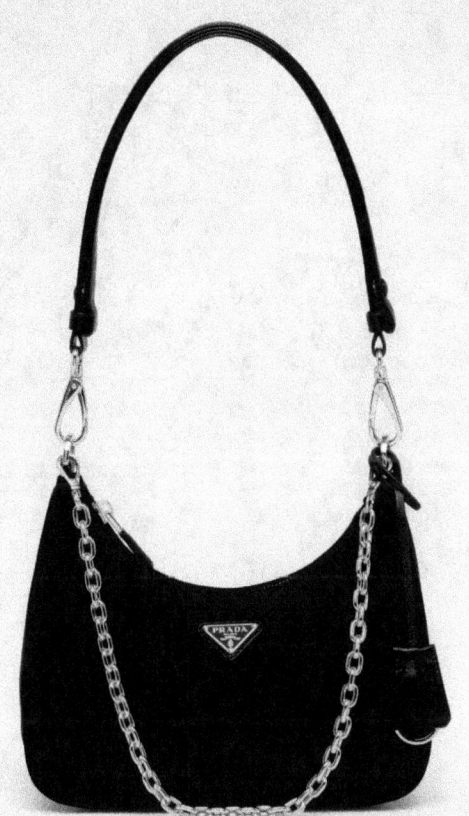

19

Prada Marfa: In 2005, a permanent art installation named Prada Marfa was created by artists Elmgreen and Dragset in Texas, depicting an isolated Prada boutique, and became a cultural phenomenon and topic of discussion in the fashion world. contemporary art.

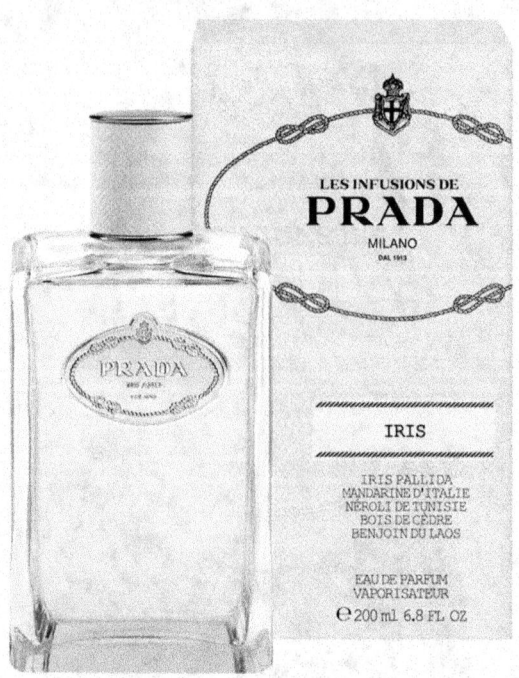

20

Prada's "Infusion d'Iris", launched in 2007, revolutionized the perfume industry with its light and sophisticated fragrance, setting a new trend for more delicate and refined perfumes.

the Art of Perfume

Prada and the Art of Perfume: An Olfactory Revolution with "Iris Infusion"

In the rich and diverse world of luxury perfumes, Prada made history with the launch of "Infusion d'Iris" in 2007, a key moment that redefined the standards of modern perfume. This fragrance has become iconic, perfectly illustrating the fusion between traditional craftsmanship and Prada's avant-garde vision, and represents a milestone in the lineage of the brand's fragrances.

A Signature Perfume
"Infusion d'Iris" stands out for its sophisticated composition, where the iris, a flower traditionally associated with royalty and luxury, plays the main role. This choice of ingredient reflects Prada's commitment to combining exceptional quality and timeless elegance. The fragrance captures the essence of iris with remarkable purity and freshness, intertwined with notes of mandarin, cedar, and benzoin, creating a scent that is both classic and contemporary.

An Olfactory Revolution
The launch of "Infusion d'Iris" was an olfactory revolution, establishing a new trend for lighter, more delicate, yet deeply sophisticated fragrances. At a time when the market was dominated by strong, opulent fragrances, "Infusion d'Iris" introduced a refreshing and distinct alternative, redefining consumer preferences and influencing the fragrance creations that followed.

With "Infusion d'Iris", Prada has not only created a perfume, but launched an olfactory signature that embodies elegance, sophistication and innovation. This fragrance has become a modern classic, testament to Prada's ability to transcend fashions and imbue collective memory with timeless creations that continue to inspire and captivate.

21

Female leadership: Miuccia Prada, at the helm of the brand since the 1970s, is one of the few women to lead a major company in the luxury fashion industry, marking the brand with her feminist influence and approach thoughtful fashion.

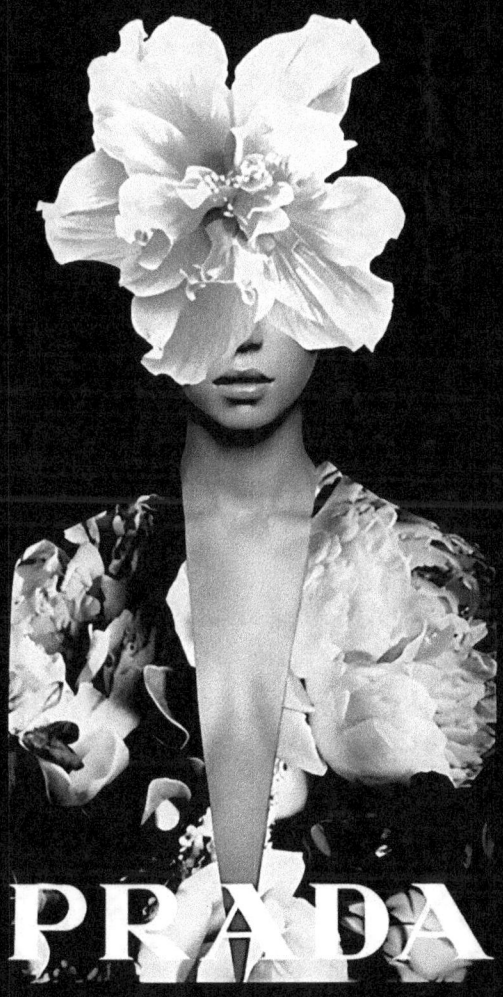

PRADA

Prada continues to be a major force in the world of fashion, thanks to its rich history, constant innovation and cultural influence. Here are ten more facts that illustrate the depth and diversity of Prada's imprint on the fashion industry and beyond

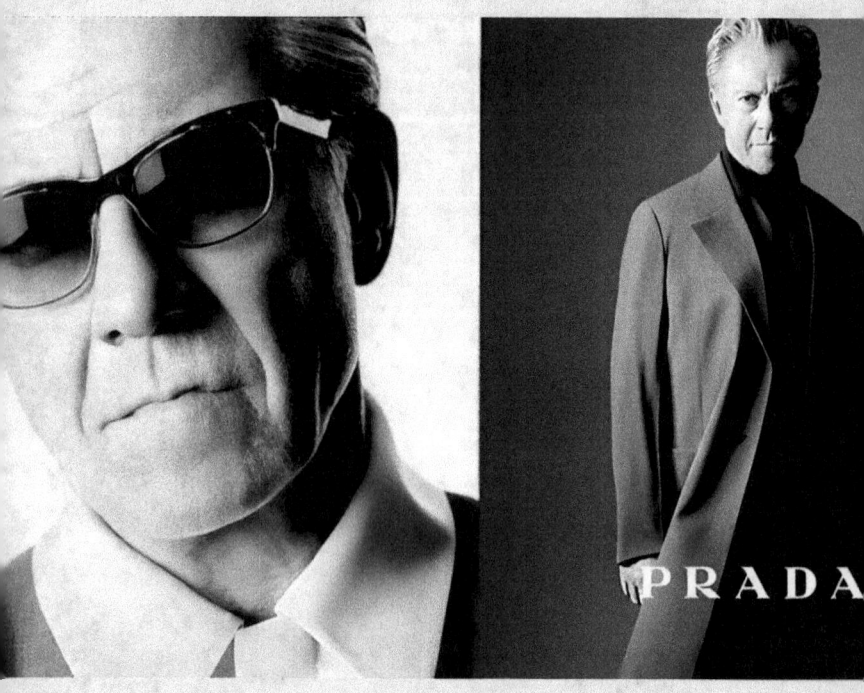

22

Strategic Acquisitions: The Prada Group, in its diversification strategy, acquired other luxury brands, such as the English shoe brand Church's in 1999, thereby strengthening its luxury brand portfolio.

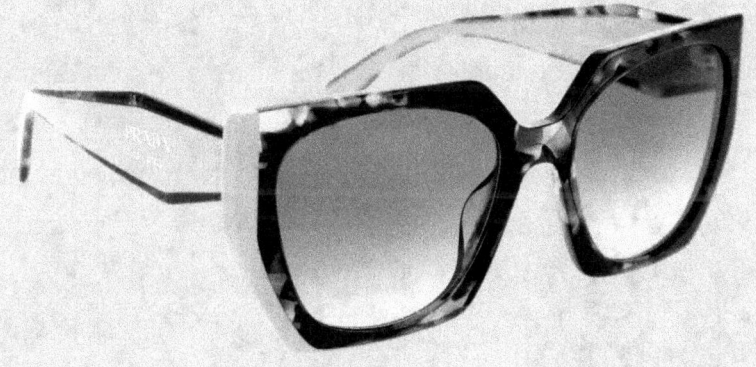

23

Prada Sunglasses: Prada is also recognized for its innovative and designer sunglasses lines, which combine high-quality materials with distinctive styles, becoming essential fashion accessories.

THE
Miuccia Prada and
Patrizio Bertelli
EDITING

history

FAMILY

G Fashion's Dynamic Duo: Miuccia Prada and Patrizio Bertelli At the heart of the Prada empire is a powerhouse duo, Miuccia Prada and Patrizio Bertelli, whose personal and professional alliance has redefined the contours of luxury fashion. Together, they transformed the Prada brand, inherited by Miuccia in 1978, into a global symbol of innovation, elegance and commercial success. This article explores the unique synergy between these two iconic figures and how their collaboration propelled Prada onto the global fashion stage.

A Determining Meeting The story of the Prada couple begins in the 1970s, when Miuccia Prada met Patrizio Bertelli, an Italian entrepreneur then producing leather goods. Bertelli immediately recognized the potential of Miuccia's creative vision and proposed a collaboration: he would handle the business side of the business while Miuccia would focus on design. This meeting marks the beginning of a prolific professional and personal relationship.

Shared Vision and Mutual Success Miuccia Prada, with her atypical background in political science and her interest in mime, brings an intellectual and revolutionary approach to fashion design, challenging conventions and expectations. Patrizio Bertelli, with his keen entrepreneurial spirit and rigorous approach to management, introduced innovative strategies for the expansion and positioning of the brand. Their union allowed Prada to flourish, perfectly balancing the art of fashion with the demands of the luxury market.

Innovation et Expansion
Under their joint leadership, Prada expanded dramatically, diversifying its portfolio to include not only leather goods but also ready-to-wear, shoes, fragrances and a variety of accessories. The couple also pioneered the use of unconventional materials, like nylon, elevating practical items to fashion icons. Their approach has always been to remain faithful to the brand's DNA while exploring new creative territories.

Cultural Engagement
Beyond fashion, Miuccia and Patrizio have invested in culture and art, evidenced by the creation of the Prada Foundation in 1993. This project illustrates their commitment to fostering critical reflection and dialogue in the arts, by offering a platform for contemporary art, cinema and philosophy. The Prada Foundation, with its spaces in Milan and Venice, has become an influential cultural center, reflecting the couple's passion for art and its impact on society.

A promising future
The Prada couple continues to lead the brand towards new horizons, with a focus on sustainability, digital innovation and social commitment. Their partnership demonstrates that merging unwavering creativity with strategic business vision can not only transform a brand but also significantly influence the fashion industry and beyond.

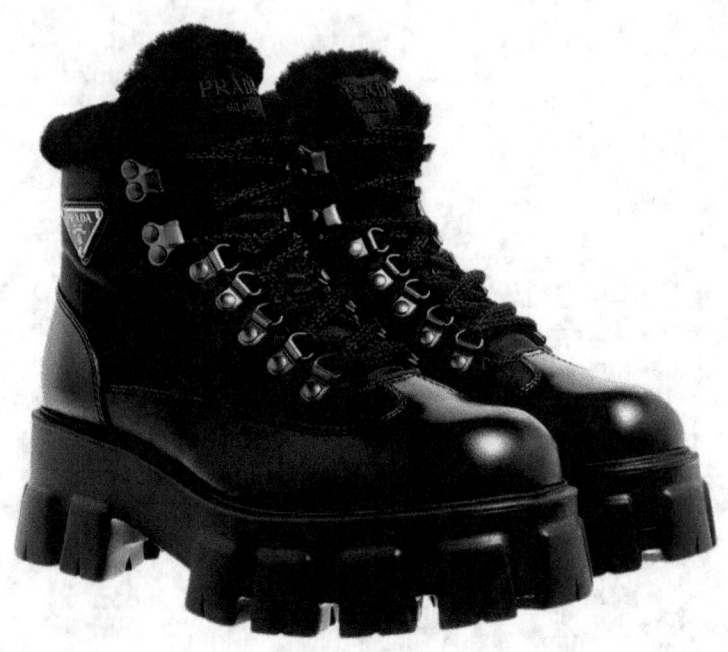

24

Use of blockchain technology: Prada, in collaboration with other luxury brands, has explored the use of blockchain technology to improve the traceability and authenticity of its products, reflecting its commitment to innovation and transparency.

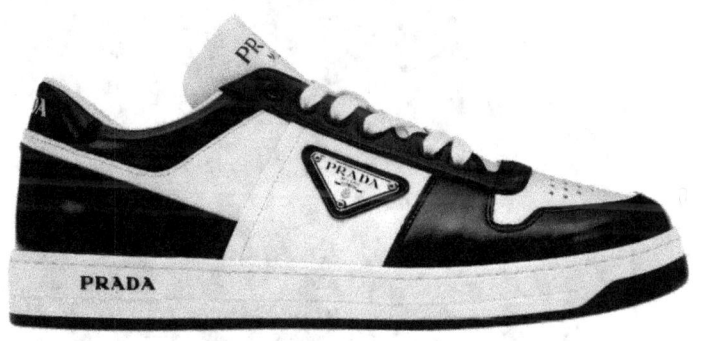

25

The **"Timecapsule"** project: Prada has launched an exclusive digital project called "Timecapsule", where the brand offers a limited series of items available only for 24 hours on the first Thursday of each month, combining exclusivity and digital experience.

26

Defense of women's rights: Beyond fashion, Prada is committed to defending women's rights, particularly through its support for various initiatives and organizations that

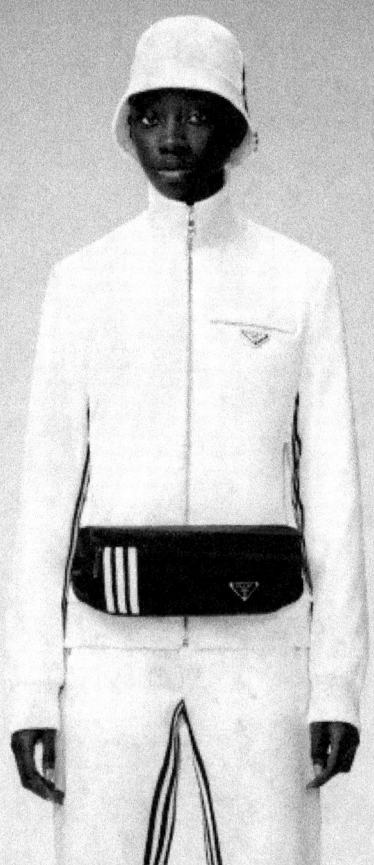

27

Fashion Show Innovations: Prada has been a pioneer in presenting virtual and hybrid fashion shows, particularly during the COVID-19 pandemic, showing its ability to adapt and innovate in the face of global challenges.

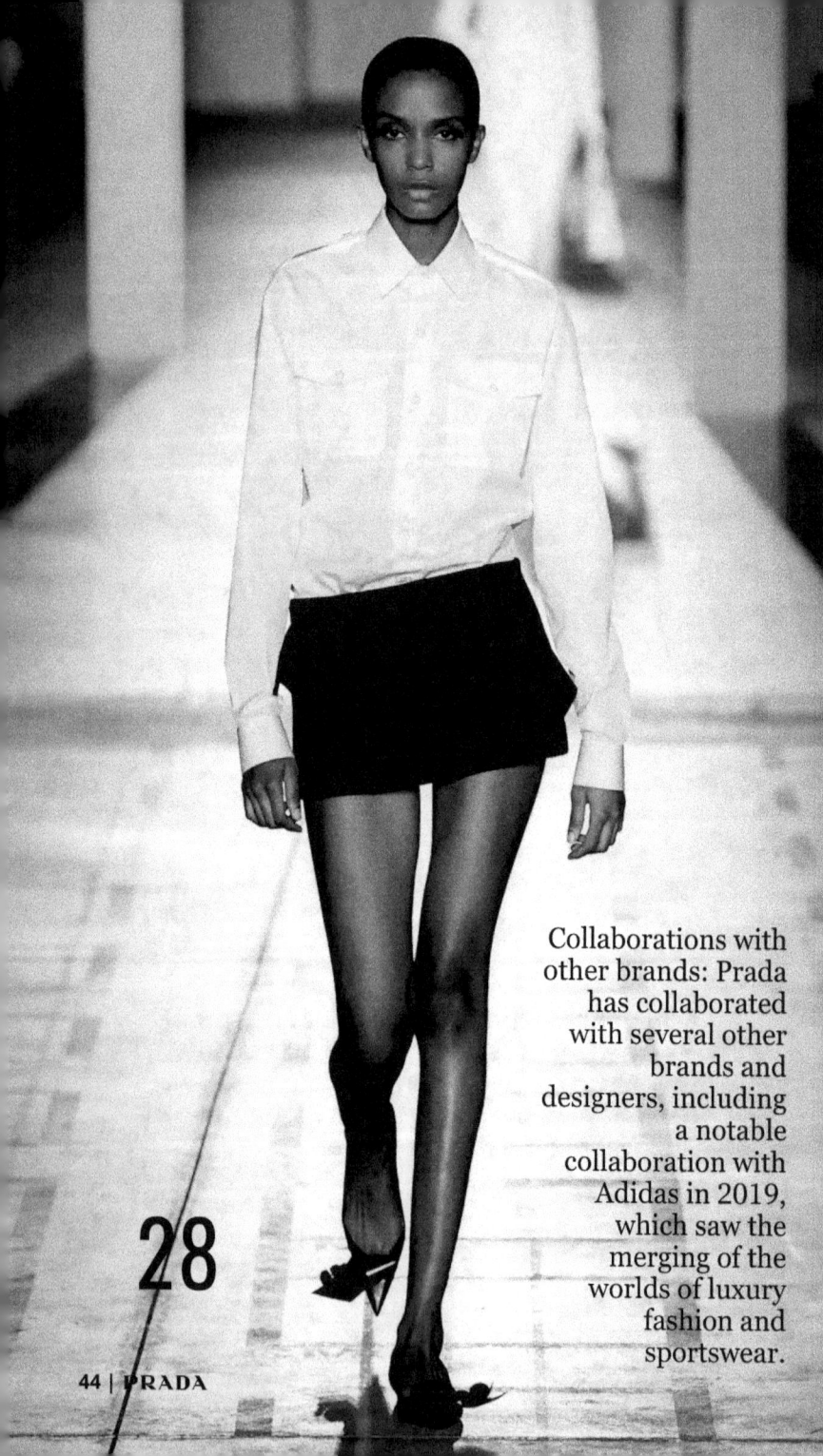

Collaborations with other brands: Prada has collaborated with several other brands and designers, including a notable collaboration with Adidas in 2019, which saw the merging of the worlds of luxury fashion and sportswear.

28

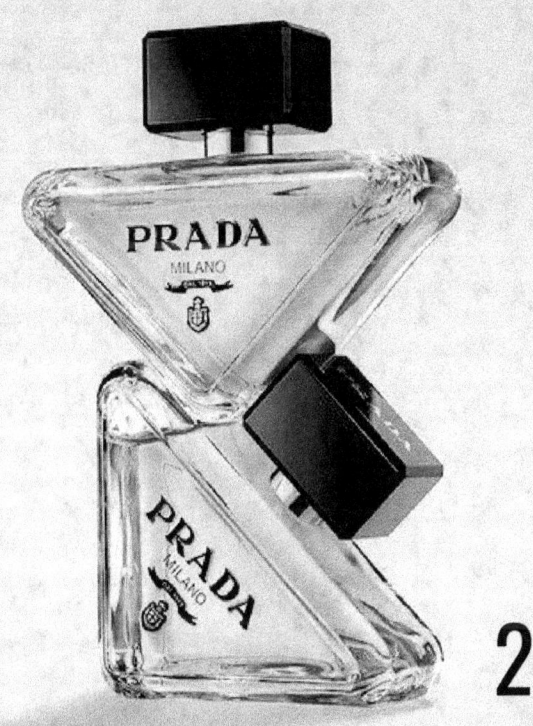

29

Cultural and social impact: Through its art, cultural initiatives and advertising campaigns, Prada has regularly sought to provoke reflection on social and cultural issues, affirming the role of fashion as a means of expression and social dialogue.

Prada Timecapsule

An Innovative Convergence between Fashion, Exclusivity and Digital In a world where fashion constantly seeks to innovate while preserving exclusivity and luxury, Prada has launched a revolutionary project, "Timecapsule", which reinvents the online shopping experience. This initiative, started in December 2019, marks a turning point for the Italian luxury brand, merging the tradition of exclusivity with the possibilities offered by digital. This article explores how Prada's Timecapsule project is redefining the boundaries of the luxury fashion experience.

The Essence of Timecapsule

Timecapsule is a unique digital initiative where Prada offers, on the first Thursday of each month, a limited edition item on sale for only 24 hours. These exclusive pieces are numbered, making each launch unique and highly desirable among fashion aficionados. Ranging from shirts to accessories, each item reflects Prada's artisanal expertise and innovative design, while offering consumers a rare collector's item.

A Bridge between Tradition and Innovation

What sets Timecapsule apart is its ability to skillfully blend tradition and innovation. On the one hand, there is the exclusivity and quality craftsmanship that have long characterized luxury products. On the other hand, Prada uses the digital platform to make this tradition accessible to a global audience, instantly and with regular frequency. This approach responds to the growing demand for unique and immersive shopping experiences that can be enjoyed remotely.

30

What sets Timecapsule apart is its ability to skillfully blend tradition and innovation

Market Response and Brand Impact:
Market reception of Timecapsule has been overwhelmingly positive, with many items selling out within minutes of going live. This enthusiastic response not only demonstrates the loyalty and commitment of Prada's customer base but also highlights the effectiveness of combining digital marketing strategies with the prestige of luxury fashion exclusivity.

Contribution to Sustainability:
By limiting production to specific, numbered editions, Timecapsule also aligns with the principles of sustainability, avoiding overproduction and emphasizing quality over quantity. This reflects Prada's growing commitment to responsible business practices, resonating with the values of modern consumers who prioritize conscious and ethical exclusivity.

Towards the Future of Luxury Fashion:
The Timecapsule project illustrates how Prada, while remaining true to its luxury roots, is constantly evolving to meet the changing expectations of its customers. By integrating digital innovation, the brand does not just sell products; it sells an exclusive and ephemeral experience that reinforces its avant-garde luxury brand image.

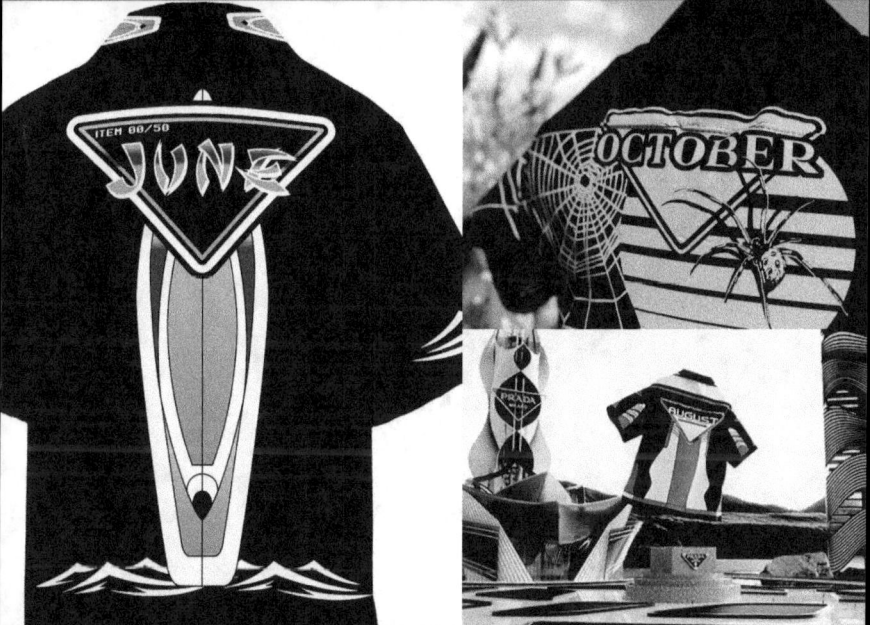

31

Prada's Timecapsule project revolutionizes the luxury fashion experience by offering, every first Thursday of the month, an exclusive limited edition piece available for just 24 hours, thus merging artisanal tradition and digital innovation.

32

The Prada logo, more than just a brand, is a statement of elegance, quality and innovation. It embodies the spirit of Prada, attracting a clientele who values not only luxury, but also the history, culture and art behind each creation. In the fast-paced world of fashion, the Prada logo remains a beacon of excellence and an enduring symbol of one of the most prestigious names in the industry.

The Prada Logo: Symbol of Elegance and Innovation in the World of Fashion

The Prada logo, with its distinctive typography and minimalist design, has become one of the most recognized and respected symbols in the world of luxury. Representing much more than just a brand, the Prada logo embodies a rich history, a tradition of excellence and a constant quest for innovation, reflecting the very essence of the Italian luxury brand.

An Iconic Visual Identity
Designed to be immediately identifiable, the Prada logo consists of the brand name in capital letters, highlighted by an elegant curved line that adds a touch of refinement. This apparent simplicity hides a depth of meaning and meticulous attention to detail, hallmarks of Prada's approach to design.

A Brand Heritage
The Prada logo is not just a symbol of luxury; it also carries a family heritage and a history beginning in 1913, when Mario Prada opened his first boutique in Milan. The brand, since its inception, has been associated with excellence in leather goods and has grown to become synonymous with haute couture, innovation and sophistication.

Evolution and Consistency
Over the years, the Prada logo has evolved while remaining true to its roots. This visual consistency reflects the brand's commitment to quality and sustainability, while subtly adapting to changes in fashion and consumer expectations. It symbolizes a bridge between Prada's prestigious past and its promising future, marked by innovation and global expansion.

33

Humble beginnings: Founded in 1913 by Mario Prada, the brand initially specialized in leather goods, particularly luggage and handbags, aimed at the European elite.

34

IPO: In 2011, Prada debuted on the Hong Kong Stock Exchange, underscoring its status as a global luxury powerhouse.

35

Prada and architecture: The brand has collaborated with renowned architects to design its stores, including Rem Koolhaas and Herzog & de Meuron, making each Prada space an architectural work of art.

PRADA SHOP OF HISTORY

REVOLUTION IN PERFUMERY

Prada fragrances embody elegance, innovation and sophistication, reflecting the very essence of the Italian luxury brand.

Each fragrance is designed with meticulous attention to detail, blending tradition and modernity in a relentless quest for olfactory perfection.

Prada's fragrance creations are distinguished by their use of premium notes, creating unique compositions that captivate and enchant.
From the emblematic "Infusion d'Iris" to the daring "Prada Candy" series, including the elegant "L'Homme Prada" and "La Femme Prada" collections, the brand succeeds in capturing in each bottle a universe rich in emotions and stories.

36

Commitment to art: Prada launched the Prada Foundation in 1993, a space dedicated to contemporary art and culture, highlighting the brand's deep commitment to art and culture.

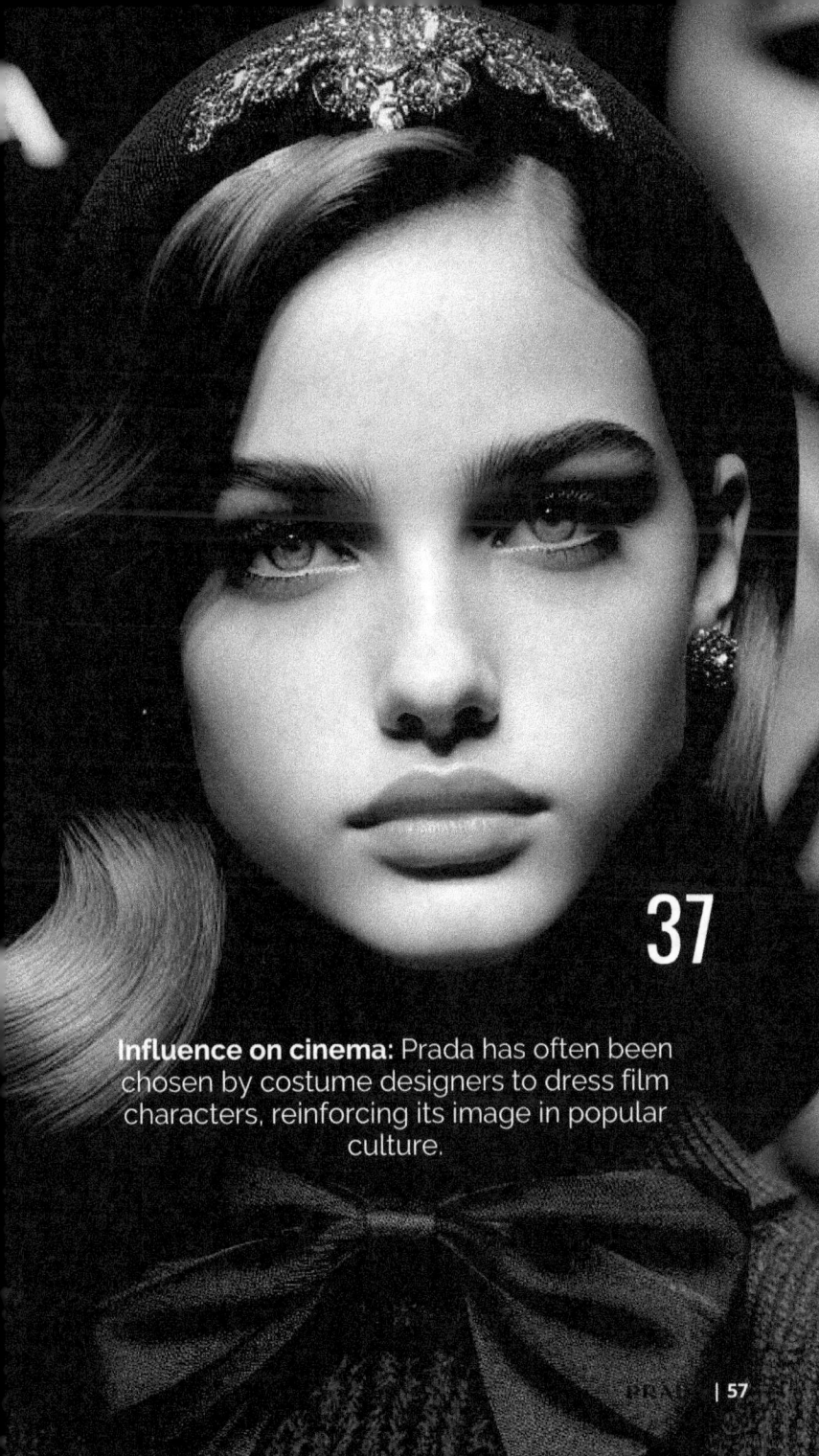

37

Influence on cinema: Prada has often been chosen by costume designers to dress film characters, reinforcing its image in popular culture.

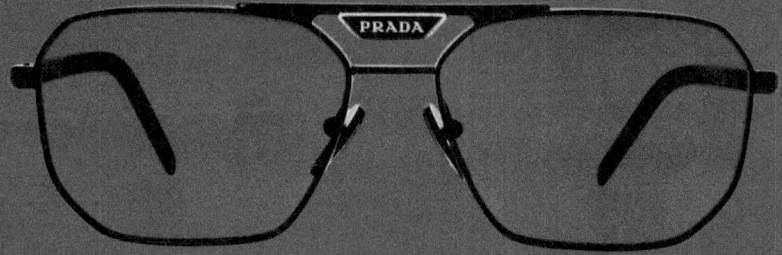

38

Prada and technology: The brand has embraced digital technology, launching innovative projects like Prada Timecapsule and exploring the use of blockchain for product authenticity.

39

Sustainability support: Prada has committed to sustainability initiatives, such as the Re-Nylon project, aimed at converting all of its nylon into recycled materials, reflecting its commitment to eco-responsible practices.

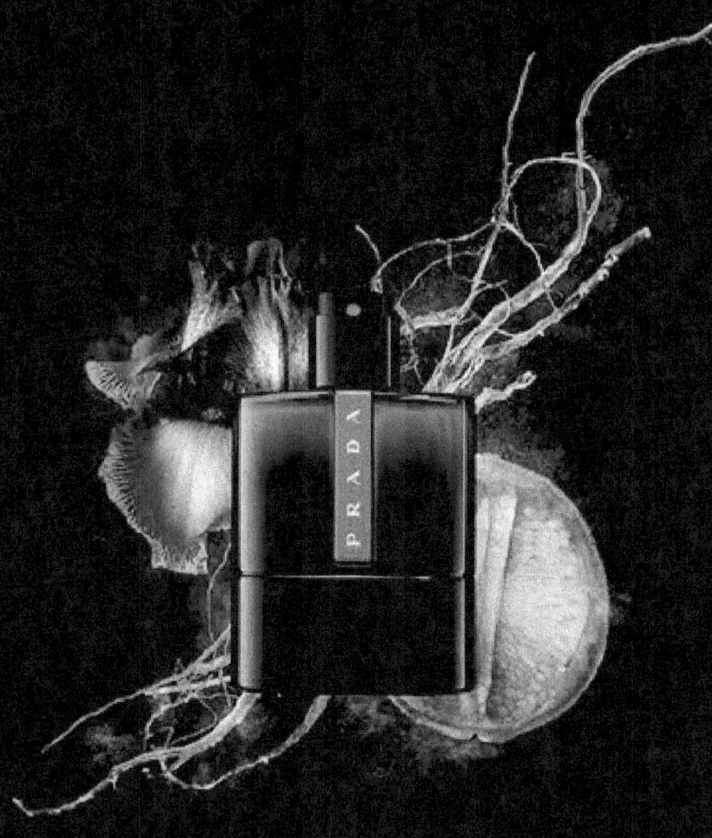

40

Expansion beyond fashion: Prada has expanded its empire to include perfumes, eyewear, and even pastries, after acquiring the famous Milanese pastry Marchesi 1824.

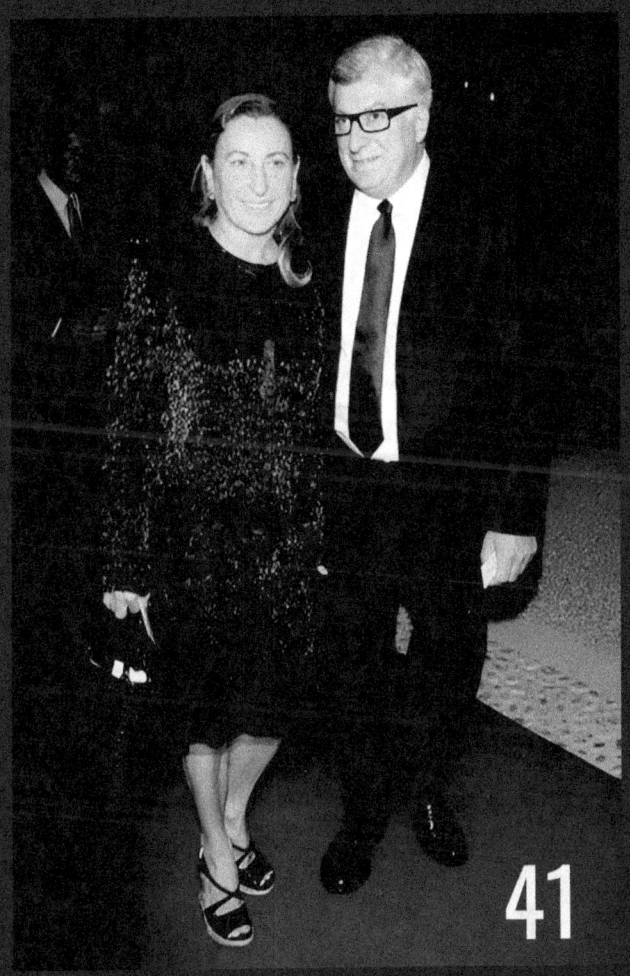

41

Female Leadership: Under the leadership of Miuccia Prada, the brand has not only thrived but also taken a forward-thinking turn, proving the impact of female leadership in the traditionally male-dominated industry.

42

Fashion Collaborations: Prada has engaged in memorable collaborations with other brands and designers, including the Prada for Adidas collection, which merges sportswear with luxury, illustrating Prada's ability to break the boundaries between different worlds of fashion. the fashion.

Presence in Museums: Prada's creations have been exhibited in museums around the world, testifying to the cultural and artistic importance of the brand. For example, the MET in New York has included Prada pieces in several of its exhibitions, recognizing their impact on fashion history.

43

44

Digital Innovations: Prada has been a pioneer in adopting augmented reality and other digital technologies to enrich the customer experience, offering innovative ways to interact with the brand in an online environment.

The Muses of Prada: Ambassadors of Elegance and Avant-Garde

At the heart of Prada's identity lies a constellation of charismatic muses, iconic figures who embody the brand's innovative spirit and timeless elegance. Over the years, Prada has surrounded itself with notable personalities from the world of fashion, cinema and culture, choosing ambassadors who reflect the values and aesthetics of the brand. This article highlights the crucial role that these muses play in the influence of Prada.

A Mosaic of Talents

Prada stands out for its choice of muses from diverse backgrounds, selected not only for their image, but also for their personality and their ability to inspire. Actors, models, artists, each brings a unique dimension to the brand, creating a dialogue between fashion and other forms of artistic expression. Prada's advertising campaigns, often narrative and cinematic, feature these ambassadors in captivating visual stories, highlighting the convergence between Prada and art.

Ambassadors of Innovation

Prada's muses are not just faces; they are the voice of a brand that values innovation, creative courage and a forward-thinking approach to fashion. By choosing personalities who challenge convention, Prada communicates its commitment to diversity, inclusion and questioning established norms. These ambassadors embody Prada's perpetual movement towards the future, while respecting its rich heritage.

A Cultural Influence

The impact of Prada's muses goes far beyond fashion. By partnering with influential players and trendsetters, Prada forges close links with contemporary culture. These collaborations are a testament to the central place Prada occupies not only in the fashion industry, but also in the broader cultural dialogue, influencing perceptions, styles and even social norms.

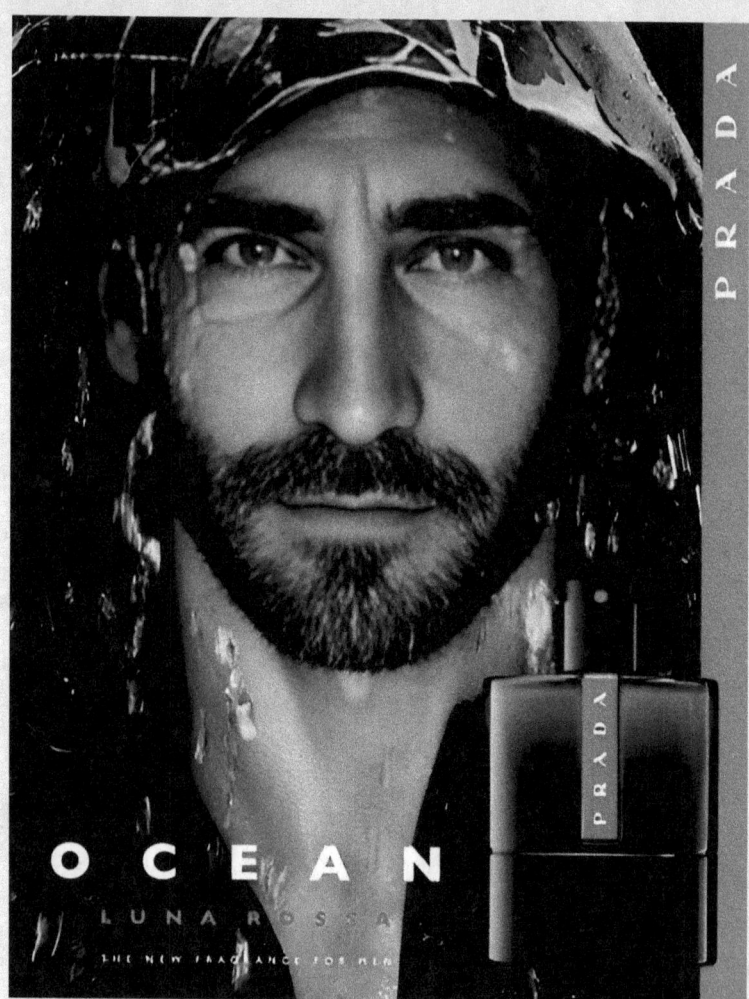

45

Jake Gyllenhaal, an actor recognized for his talent and versatility, was chosen as the face of the Prada Luna Rossa Ocean perfume campaign in 2021, embodying the fragrance's spirit of adventure and innovation.

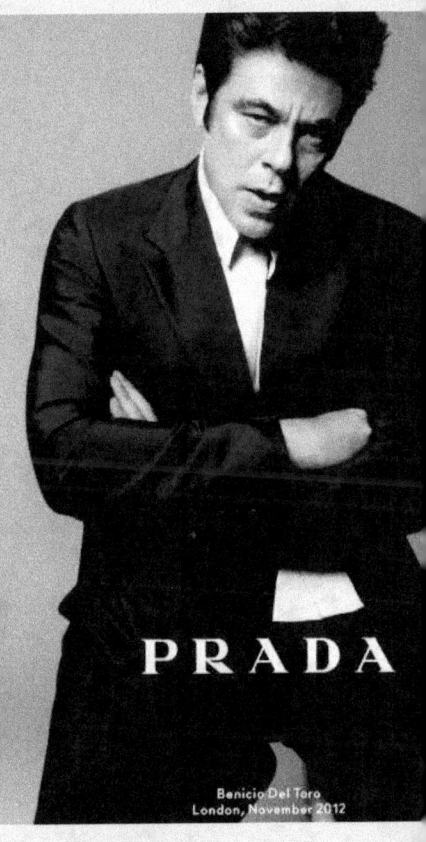

Benicio Del Toro
London, November 2012

46

Benicio Del Toro, an actor acclaimed for his intense and charismatic roles, was one of Prada's muses, appearing in the advertising campaign for the Fall/Winter 2013 Men's collection, bringing a touch of mystery and raw elegance to the brand.

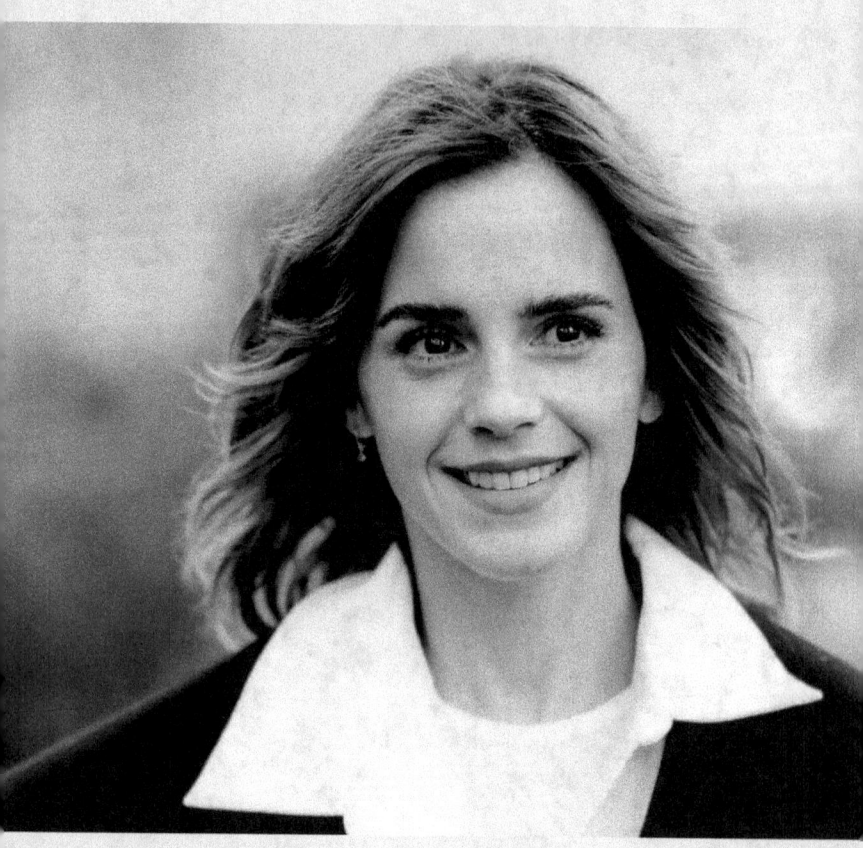

47

Emma Watson, muse of Prada. The actress and activist is well known for her conscious fashion choices and commitment to sustainable causes, which could align her values with those of Prada, particularly in their initiative towards sustainability and innovation.

48

The Prada Cup in Sailing: Prada has extended its influence beyond fashion by sponsoring the Prada Cup, a regatta that determines the challenger for the America's Cup, one of the most prestigious sailing competitions in the world, highlighting thus its commitment to excellence and luxury in all areas.

49

Prada's Anti-Logo Approach: In the 2000s, Prada adopted an anti-logo approach, focusing on design and quality rather than ostentatious brand display, a move that reinforced its image of discreet luxury brand.

50

The "Prada Classics" Series: Prada has reissued iconic pieces from its archives under the name "Prada Classics", allowing aficionados of the brand to own a part of its history.

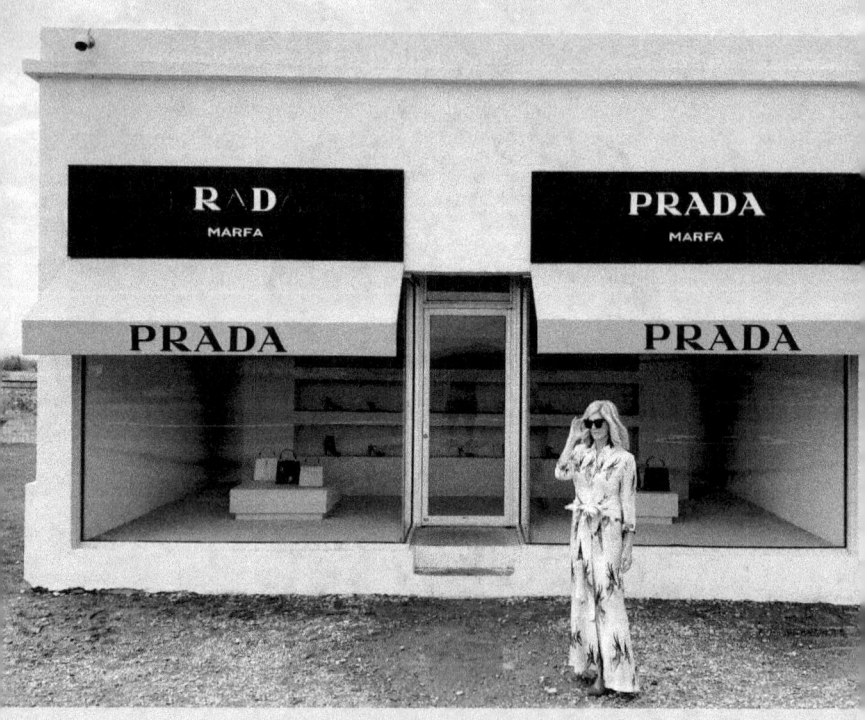

51

The Prada Marfa Project: Prada Marfa is a permanent art installation in Texas, created by artists Elmgreen and Dragset. Resembling an isolated Prada boutique, it has become a cultural symbol discussing themes of consumption and brand identity.

52

Transition to Ready-to-Wear: Under the leadership of Miuccia Prada, the brand expanded its range to women's ready-to-wear in the 1980s, revolutionizing the approach to fashion with innovative and intellectual designs.

Black & luxe **Best style**

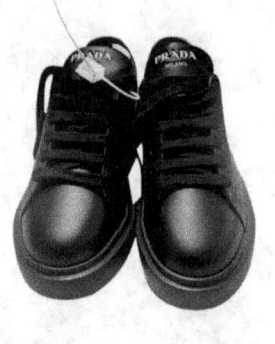

black bloom
PRADA FASHION
THE BLACK

Prada's Black shoes, with their iconic blend of timeless elegance and modern flair, perfectly embody the epitome of understated luxury. Each pair is the result of a masterful fusion of traditional craftsmanship and stylistic innovation, characteristics that define Prada's approach to design. Designed to transcend passing trends, these shoes stand out for their exceptional quality, reflecting the brand's commitment to excellence.

53

Launch of the Men's Line: In 1995, Prada launched its first men's ready-to-wear collection, quickly establishing the brand as a key player in high-end men's fashion.

54

Introduction of the Miu Miu line: In 1993, Miuccia Prada launched Miu Miu, a fashion line named after her nickname and aimed at a younger audience, highlighting a more rebellious and avant-garde aesthetic.

PRADA
AND CINEMA

55

Prada and Cinema: The brand has often collaborated with the film industry, creating costumes for iconic films, which has furthered its cultural influence far beyond fashion.

56

Digital Innovations: Prada has been a pioneer in the adoption of digital technology in fashion, from its e-commerce website launched in the 2000s to its recent augmented reality initiatives.

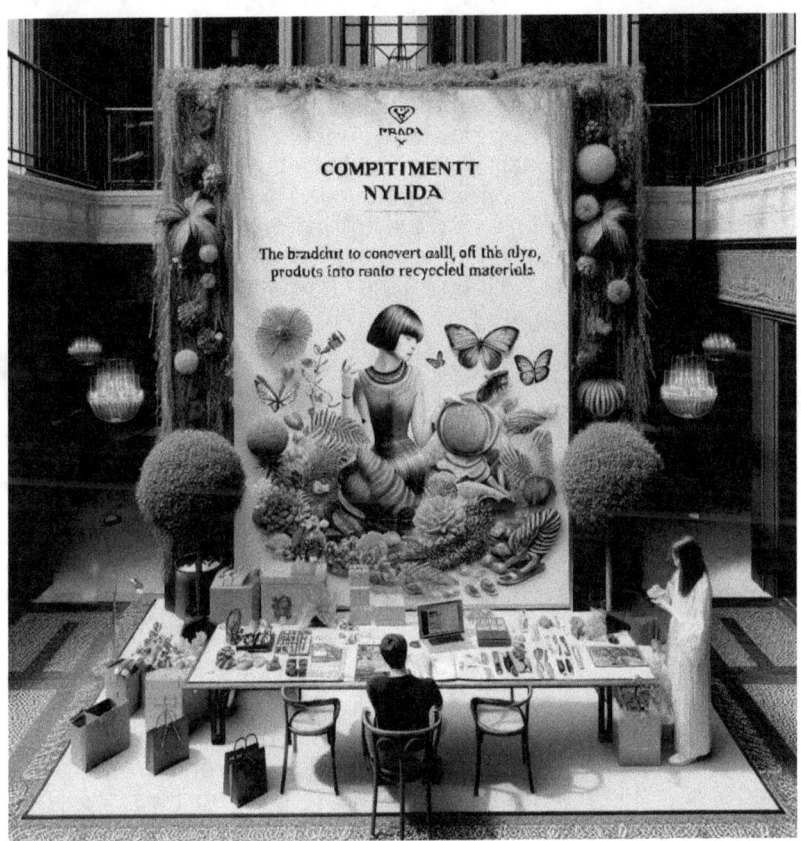

57

Commitment to Sustainability: The brand has taken significant sustainability initiatives, such as the Re-Nylon project, aimed at converting all of its nylon products into recycled materials.

Prada: Pioneer of Sustainability in the Luxury Universe

In a world where environmental awareness is becoming increasingly crucial, Prada stands out for its strong commitment to sustainability. The Italian luxury brand, recognized worldwide for its innovation and elegance, takes a proactive approach to reduce its environmental impact and promote more responsible fashion practices. This article explores how Prada is leading the charge towards a sustainable fashion future.

A Sustainable Vision

Under the creative direction of Miuccia Prada and the strategic leadership of Patrizio Bertelli, Prada has integrated sustainability into the heart of its business philosophy. Recognizing the urgency of environmental issues, Prada is committed to minimizing its ecological footprint through various initiatives, marking a turning point in the luxury fashion industry.

The Re-Nylon Project

One of Prada's flagship sustainability projects is the launch of Re-Nylon, a revolution in the production of its iconic nylon bags. Prada has replaced traditional nylon with a recycled alternative, produced from plastic waste collected from oceans, fishing nets and textile waste. This ambitious initiative demonstrates Prada's commitment to closing the life cycle of its products, transforming them from waste into valuable resources.

Eco-responsible Objectives

Beyond Re-Nylon, Prada is committed to a global sustainability approach, working to reduce its CO_2 emissions, save energy and optimize the use of water in its production processes. The brand has also invested in the development of sustainable materials and the promotion of the circular economy within the fashion industry.

Finance at the Service of Sustainability

Prada has also innovated in sustainable finance, by issuing a sustainability-linked loan, the interest of which varies depending on the achievement of specific environmental objectives. This innovative financial strategy highlights the brand's commitment to integrating sustainability criteria into all aspects of its business.

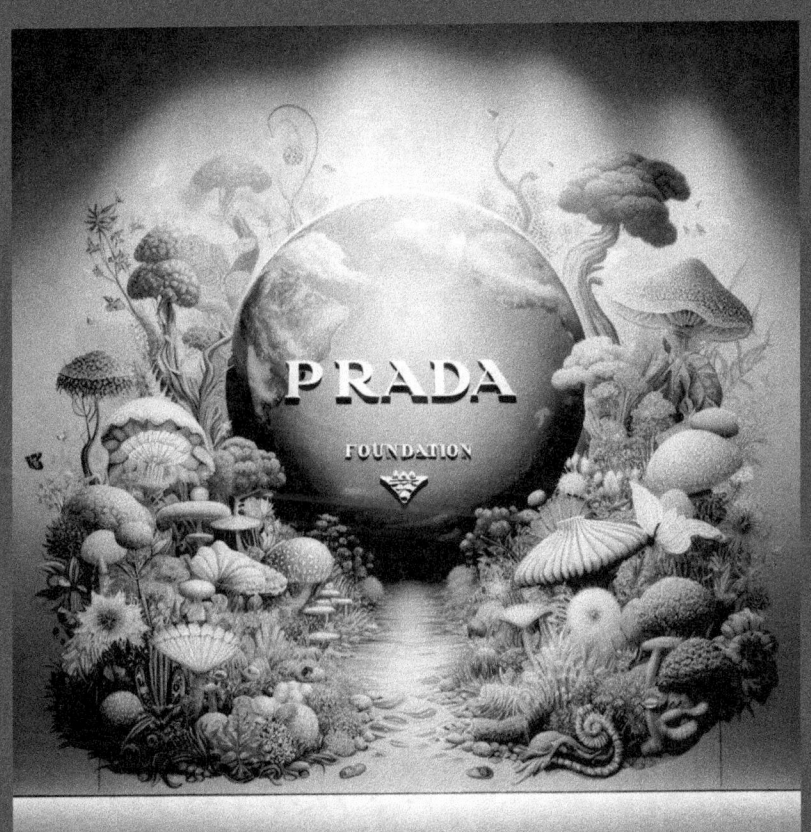

58

A Cultural and Educational Commitment Aware of its influence, Prada strives to raise awareness of the environmental cause, not only within the industry, but also among the general public. Through the Prada Foundation and various cultural initiatives, the brand encourages dialogue on sustainability, art and innovation, promoting broader thinking about the impact of fashion on our planet.

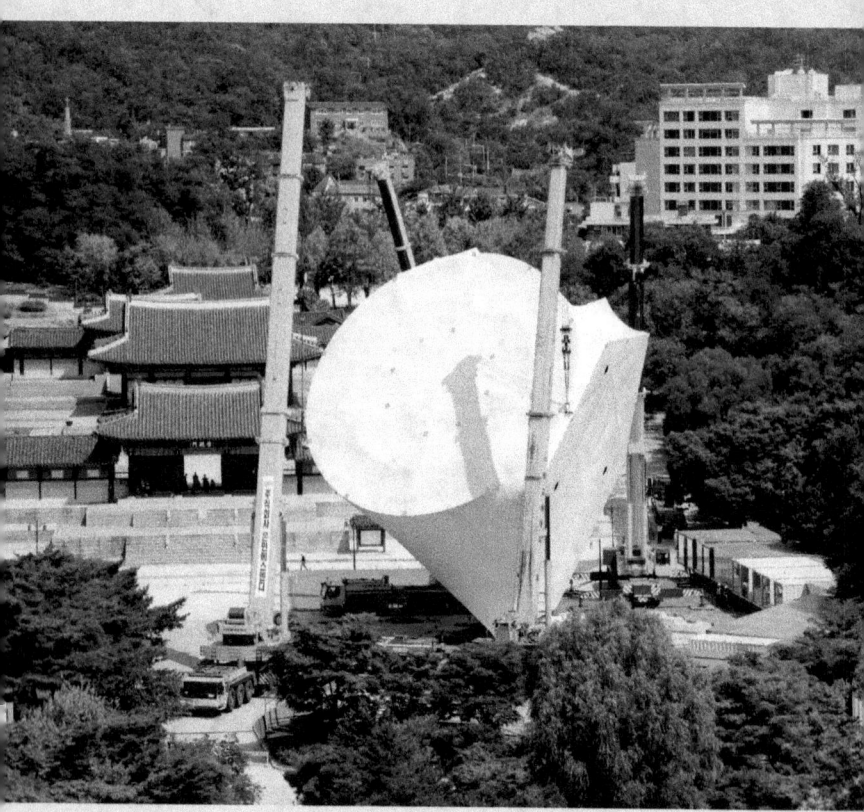

59

Prada Transformer in Seoul: In 2009, Prada launched the Prada Transformer in Seoul, a multi-purpose structure designed by architect Rem Koolhaas, illustrating the brand's commitment to art and architecture.

60

Prada Foundation in Milan: Inaugurated in 2015, the Prada Foundation is a cultural space dedicated to contemporary art, culture and science, reflecting the brand's deep commitment to diverse forms of artistic and intellectual expression.

61

Prada's commitment to sustainability is a shining example of how luxury brands can play a crucial role in combating climate change and environmental degradation. By adopting more responsible practices and advocating change within the fashion industry, Prada is not only preserving its heritage of innovation and elegance, but also paving the way towards a more sustainable future for all.

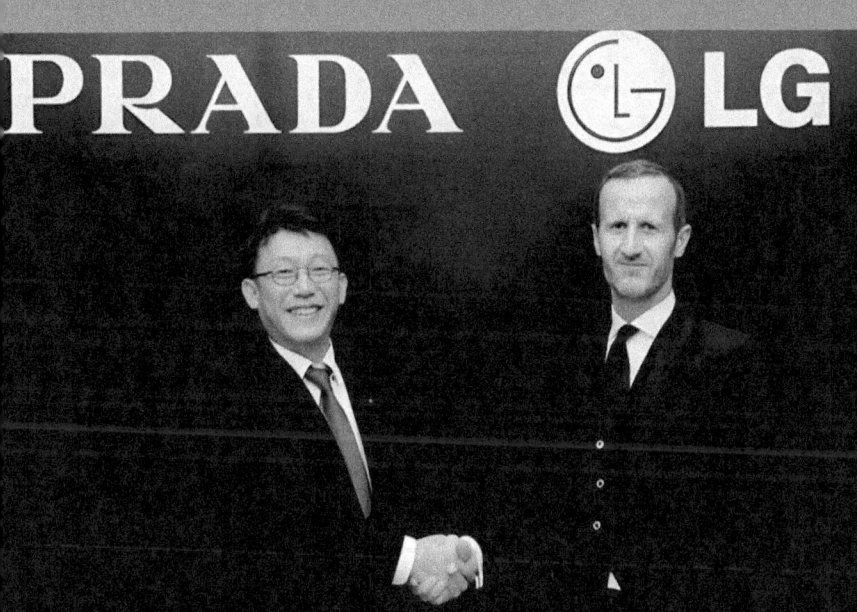

62

Collaboration with LG: In 2007, Prada collaborated with LG Electronics to create the LG Prada phone, one of the first touchscreen phones on the market, heralding the era of designer and functional smartphones.

Support for Young Artists: Through the Prada Foundation, the brand actively supports young artists and designers by providing them with platforms to exhibit their works, affirming its commitment to culture and artistic innovation.

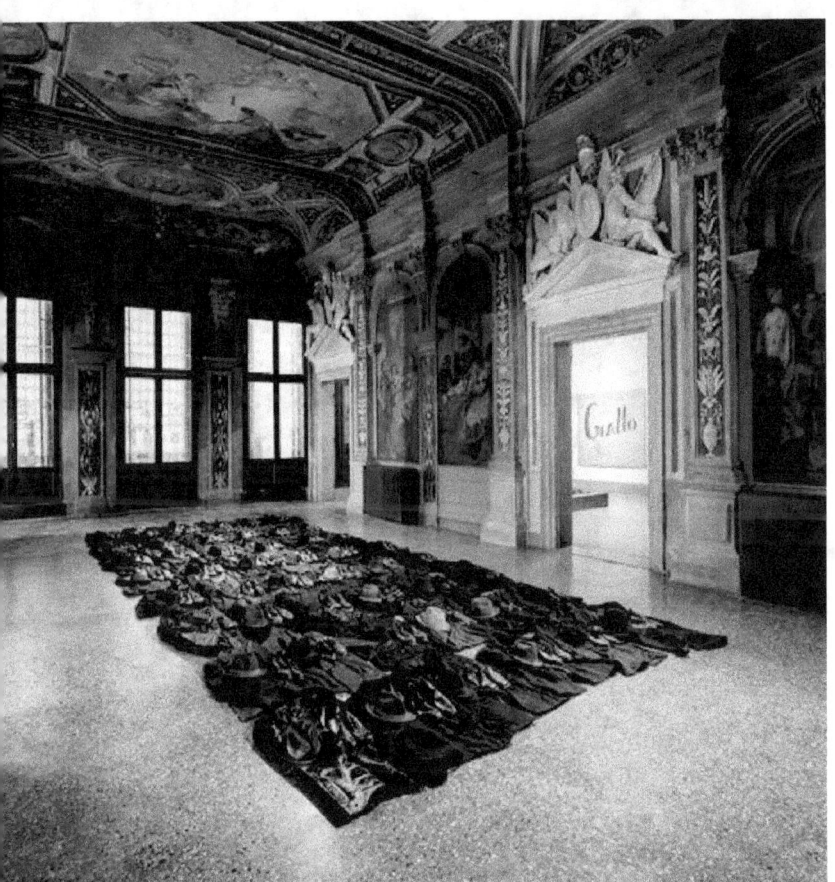

64

Prada and Architecture: In addition to its collaborations with architects to design its stores, Prada has also invested in the restoration of the historic Ca' Corner della Regina, an 18th century Venetian palace, to turn it into an exhibition space 'contemporary art.

65

Fabric Innovations: Prada introduced the technical fabric Prada Tessuto, developing unique textiles that combine aesthetics and functionality, and which have become key elements of its collections.

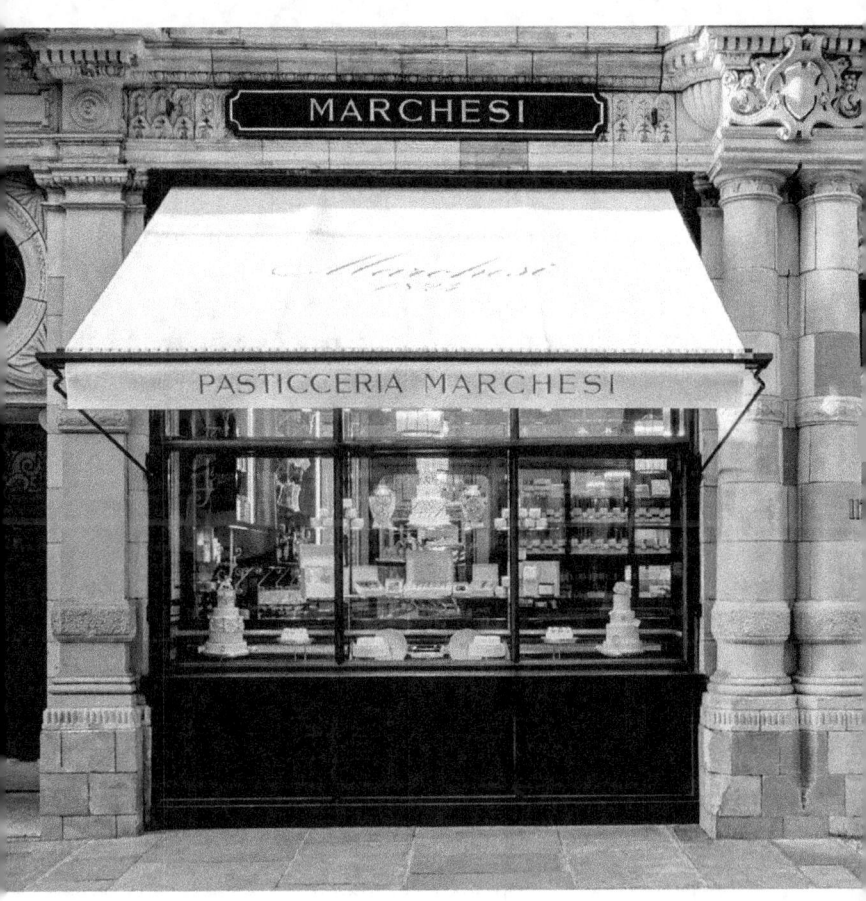

66

Marchesi 1824: In 2014, Prada acquired 80% of historic Milanese pastry shop Marchesi 1824, expanding its luxury gastronomy empire while preserving and promoting Italy's culinary heritage.

The acquisition of 80% of the historic Milanese pastry shop Marchesi 1824 by Prada in 2014

represents a remarkable step in the diversification strategy of the Italian luxury brand. Founded in 1824, Pasticceria Marchesi is one of Milan's most revered pastry shops, known for its artisan delicacies, fine chocolate and traditional Italian pastries. This movement illustrates how Prada, beyond its heritage in fashion, seeks to preserve and celebrate Italy's rich cultural and culinary heritage.

A Fusion of Luxury and Tradition
Prada's entry into the world of luxury gastronomy with Marchesi 1824 underlines a desire to merge luxury and tradition, bringing its expertise in design, quality and excellence to the field of fine pastry. This collaboration between two Milanese icons has allowed Marchesi 1824 to expand its presence, opening new points of sale in strategic locations, while maintaining its commitment to craftsmanship and quality.

Expansion et Modernisation
Under the Prada umbrella, Marchesi 1824 has not only modernized its existing facilities but also expanded its footprint by opening new spaces, including in prestigious locations like Via Monte Napoleone in Milan, one of the most luxurious neighborhoods of global shopping. These new spaces combine the timeless elegance and welcoming ambiance, characteristic of Marchesi, with a touch of modernity and sophistication specific to Prada.

Promoting Italian Culinary Heritage

Prada's investment in Marchesi 1824 goes beyond simple business expansion; it reflects a deep commitment to valuing and promoting Italian culinary heritage. By preserving traditional recipes while exploring new creations, Marchesi 1824 under the aegis of Prada has become a symbol of gastronomic luxury, where history and innovation meet.

68

Cultural and Social Impact

The combination of Prada and Marchesi 1824 demonstrates the unique ability of fashion to influence other areas, notably gastronomy. This initiative not only strengthened Prada's brand image as a symbol of Italian elegance and luxury but also contributed to the cultural and social dynamics of Milan, making Marchesi a popular meeting place for both locals and by visitors from all over the world.

Prada's acquisition of **Marchesi 1824** is an eloquent example of how luxury can serve as a bridge between tradition and modernity, between gastronomy and fashion. This successful partnership highlights Prada's commitment to enrich and diversify its offering while celebrating and preserving Italy's cultural and culinary heritage, affirming its role as guardian of Italian excellence and craftsmanship .

70

Prada Double Club Miami: In 2017, Prada collaborated with artist Carsten Höller to create Prada Double Club Miami, an immersive art project combining art installation, nightclub and performance space, exploring the boundaries between art and social life.

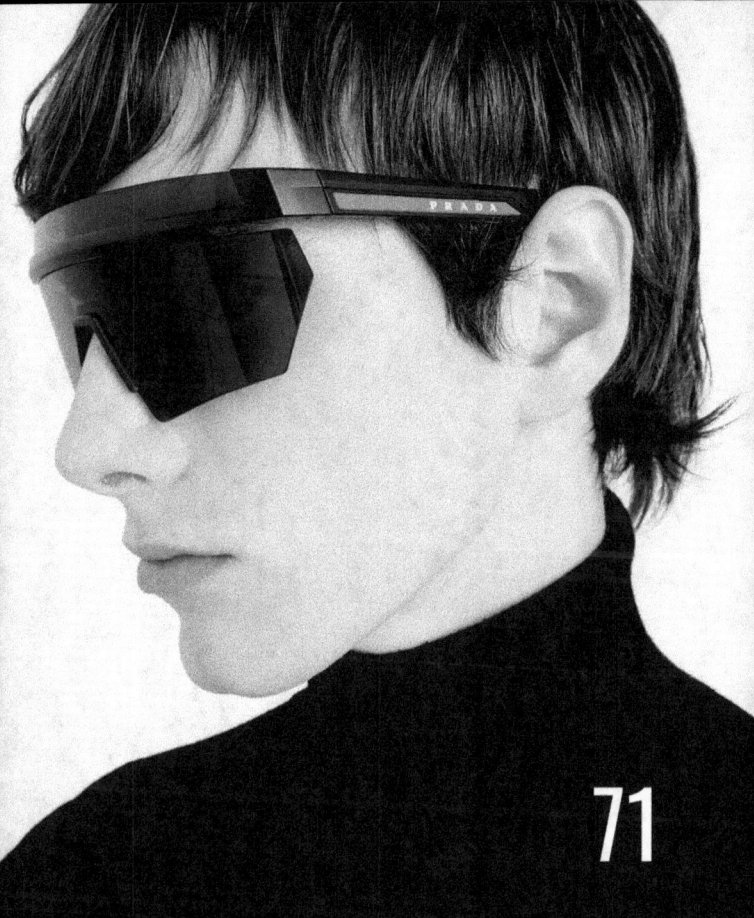

71

Prada Linea Rossa: Relaunched in 2018, the Prada Linea Rossa line merges fashion and high performance, offering premium sportswear and accessories that reflect the brand's commitment to innovative design and technology.

Sea Beyond Project: Prada launched the "Sea Beyond" educational project to raise awareness among younger generations about the protection of the marine environment, in partnership with UNESCO and its Man and the Biosphere Program.

The "Sea Beyond" project is a pioneering initiative by Prada that demonstrates its deep commitment to sustainability and ocean conservation. Launched in partnership with UNESCO and its Man and the Biosphere Program, "Sea Beyond" aims to educate and raise awareness among younger generations about the importance of protecting the marine environment. This educational project reflects Prada's growing awareness of its role in promoting sustainable and responsible practices.

——— SEA BEYOND PRADA

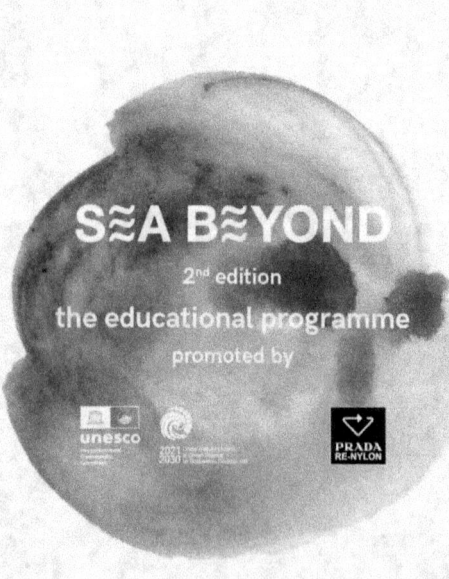

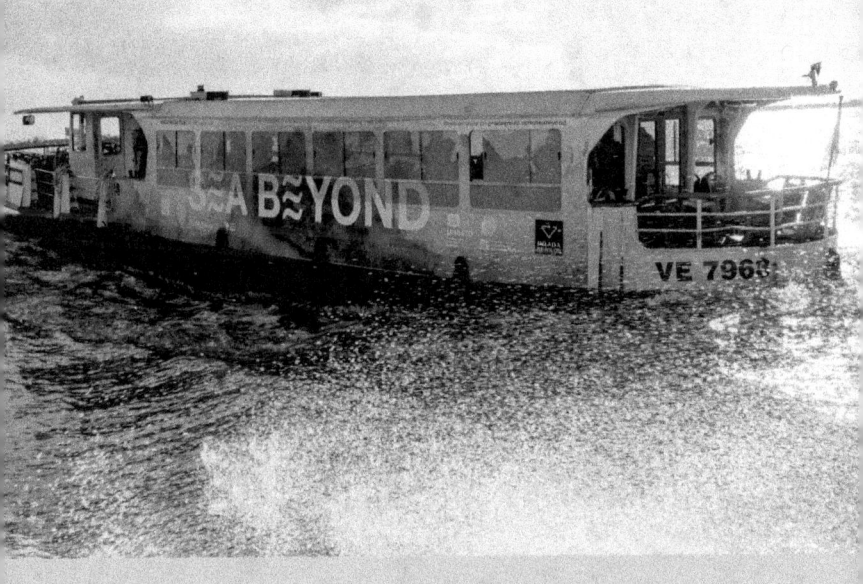

72

"Sea Beyond" is designed to provide young people with an in-depth understanding of the environmental challenges facing the oceans, such as pollution, climate change, and biodiversity loss. Through interactive educational programs, workshops, and hands-on activities, the project aims to inspire a new generation of environmental stewards, equipped with the knowledge and tools needed to contribute to the protection of marine ecosystems.

SEA BEYOND

73

Collaboration Internationale
The partnership between Prada and UNESCO highlights the importance of international collaboration in tackling environmental issues. By leveraging the resources and expertise of two renowned organizations, "Sea Beyond" benefits from a strong platform to reach a global audience, highlighting the impact such collaborations can have in environmental awareness and action.

SEA BEYOND
STUDENTS AWARD CEREMONY

74

Impact and Reach
Since its launch, "Sea Beyond" has reached schools and communities across the world, highlighting the critical importance of environmental education in building a sustainable future. With a focus on youth, Prada and UNESCO aim to cultivate ecological awareness from an early age, thereby encouraging long-term behavioral changes towards greater environmental responsibility.

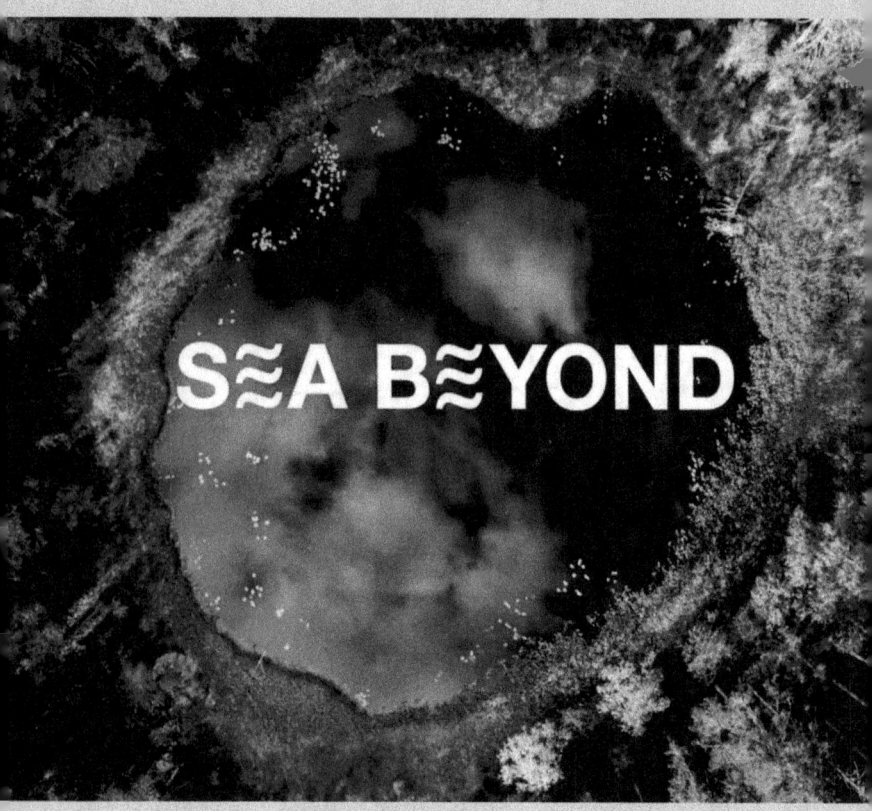

75

Prada Sustainable Commitment

The "Sea Beyond" project is part of a series of initiatives undertaken by Prada to strengthen its commitment to sustainability. Through actions such as developing recycled materials, minimizing the carbon footprint, and supporting environmental research, Prada demonstrates a holistic approach to corporate responsibility, where environmental protection takes center stage. central.

76

With "Sea Beyond", Prada strengthens its leadership role in luxury to become a key player in environmental education and marine conservation. This project illustrates how brands can use their influence to promote positive change, engaging younger generations in preserving our planet for decades to come. In partnership with UNESCO, Prada demonstrates that collaboration between the private sector and international organizations can lead to meaningful and sustainable initiatives in favor of the environment.

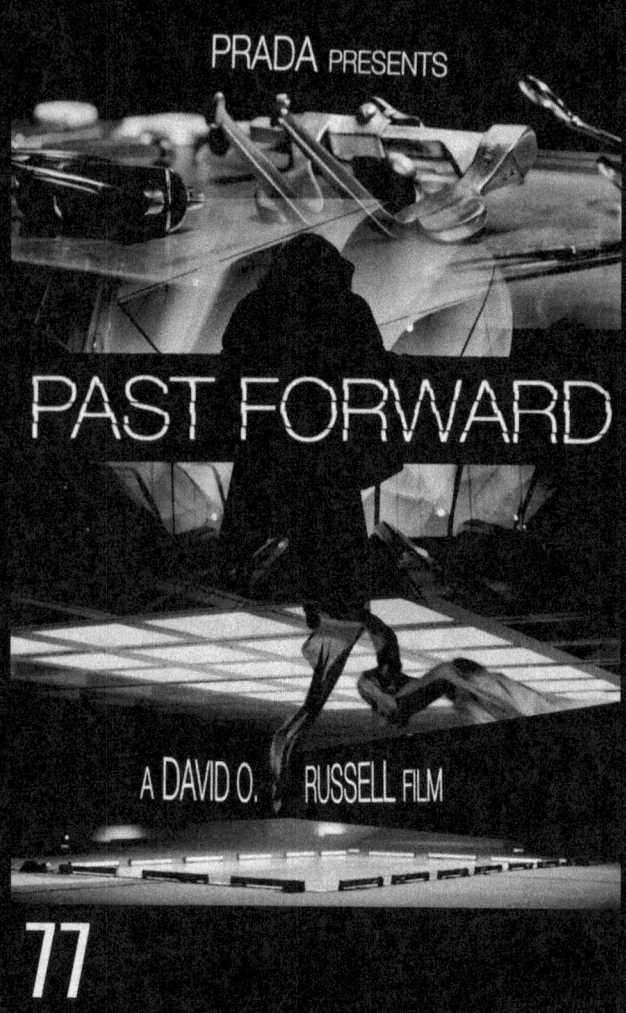

"Past Forward" Short Film Series: In 2016, Prada collaborated with director David O. Russell on a series of short films titled "Past Forward," offering a unique cinematic experience that blends art, cinema and fashion.

The 2016 collaboration between Prada and famous director David O. Russell

on the series of short films "Past Forward" represents a remarkable fusion between the worlds of fashion and that of cinema. This ambitious project marked a landmark moment in Prada's history, illustrating its commitment to artistic innovation and visual storytelling. "Past Forward" was conceived as a unique cinematic experience, blending art, cinema and fashion in a way that challenges traditional conventions and expectations.

A Shared Artistic Vision

David O. Russell, known for acclaimed films such as "American Hustle" and "Silver Linings Playbook," brought his distinctive cinematic vision to the project, working closely with Miuccia Prada. The result is a visual work of art that transcends genres, an experimental piece that explores themes like dreams, reality, and individual perception through a series of interconnected sequences.

Innovative Cinematic Experience

"Past Forward" presents itself as a silent dream, a modern silent film that invites viewers to project their own interpretations and meanings onto the events on screen. The film features a diverse cast, including actors such as Allison Williams, Freida Pinto, and John Krasinski, who navigate through a series of surreal and evocative scenarios, each dressed in Prada creations, emphasizing the interconnectedness between the characters and their environments visuals.

Fashion as a Visual Language

In "Past Forward", fashion plays a central role, not only as an aesthetic element, but also as a means of narrative expression. The Prada clothing worn by the characters becomes an extension of their identity and contributes to the overall atmosphere of the film. This seamless integration of fashion into cinema illustrates Prada's ability to push the boundaries of creativity and redefine modes of artistic expression.

Reception and Impact

Upon its release, "Past Forward" was featured in a special event in Los Angeles and was widely distributed across Prada's digital platforms, allowing a wide international audience to experience the film. The enthusiastic reception from audiences and critics alike highlighted the success of this collaboration in creating thought-provoking and visually captivating work, reinforcing Prada's status as a pioneering brand at the intersection of fashion and art.

The "Past Forward" short film series is a shining example of how Prada embraces and merges different art forms to create unique and immersive experiences. By collaborating with David O. Russell, Prada not only strengthened its commitment to art and cinema but also offered a new perspective on how fashion can enrich and expand the cinematic discourse, affirming its role as a brand innovative and avant-garde in the contemporary cultural landscape.

78

The film premiered at an exclusive event in Los Angeles, followed by a special screening in Milan in November 2016. What makes this premiere particularly interesting is how it transcended the box traditional film screening to transform into an immersive cinematic experience, reflecting Prada's innovative approach to fashion and art.

The event brought together a diverse audience, ranging from celebrities from the world of cinema to influential figures in fashion, art and culture, highlighting the unique intersection between these different fields that Prada constantly seeks to explore. The screening of "Past Forward" served as the backdrop to a broader experience that engaged guests in a dialogue about the relationship between fashion, film and art, perfectly illustrating the vision of Miuccia Prada and David O. Russell to create work that challenges traditional classifications and encourages personal interpretation.

80

This multidisciplinary approach not only showcased Prada's collection in a cinematic context but also reinforced the idea that fashion and cinema are art forms that complement and enrich each other, demonstrating the power of visual storytelling across creative disciplines.

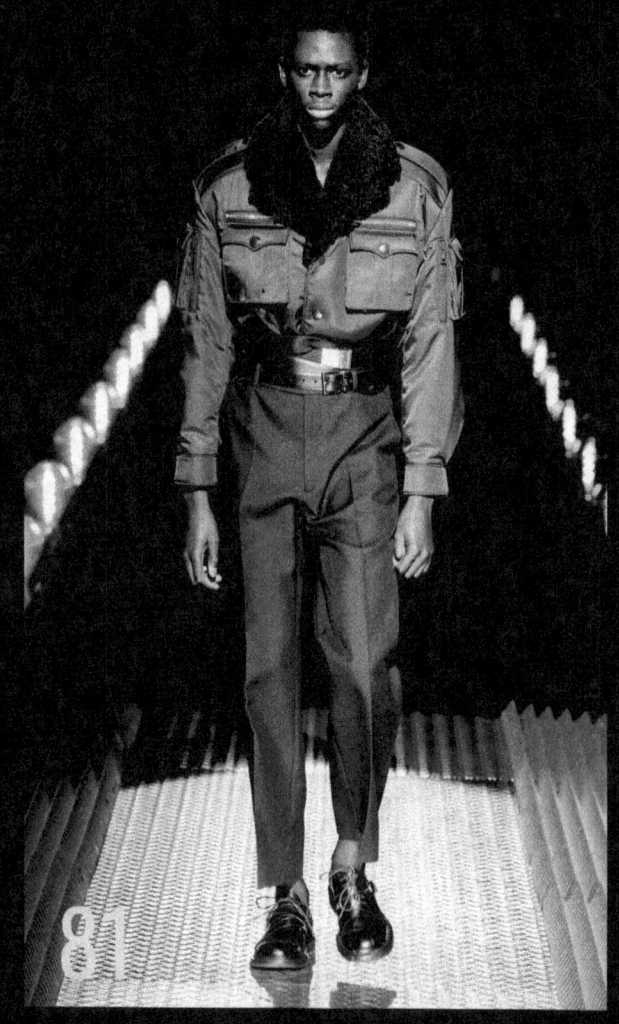

Innovative Shows: Prada is known for its groundbreaking fashion shows that transcend mere fashion spectacle to become artistic and cultural experiences, often incorporating elements of performance art and avant-garde installations.

Prada's Innovative Fashion Shows: At the Crossroads of Fashion, Art and Culture

In the dynamic world of haute couture, Prada stands out for its fashion shows, which regularly exceed traditional expectations to deliver immersive experiences at the intersection of fashion, art and culture. These presentations, much more than simple fashion shows, are true artistic and cultural manifestations, reflecting the avant-garde vision of Miuccia Prada and the innovative spirit of the brand.

A Stage for Innovation

Each Prada show is a platform for innovation, where the limitless creativity of Miuccia Prada and her team is manifested not only through the clothes presented but also in the way these clothes are introduced to the world. Prada's shows are known for their ability to integrate elements of performance art, avant-garde installations and theatrical staging, transforming each collection into a captivating visual narrative.

Fusion of Art and Fashion

One of the most remarkable aspects of Prada shows is their effortless fusion of art and fashion. By collaborating with renowned artists, architects and designers, Prada creates unique environments for its shows, often populated with artistic installations and innovative settings. These collaborations transcend traditional boundaries of fashion and art, offering a new perspective on how clothing can be experienced and enjoyed.

Immersive Experiences

Prada shows are designed to be immersive experiences, engaging audiences through all the senses. Whether through the use of innovative technologies, specially composed music or decorations radically transforming the space, every detail is designed to enrich the overall experience. These presentations don't just show clothes; they invite spectators to enter a world where fashion meets imagination.

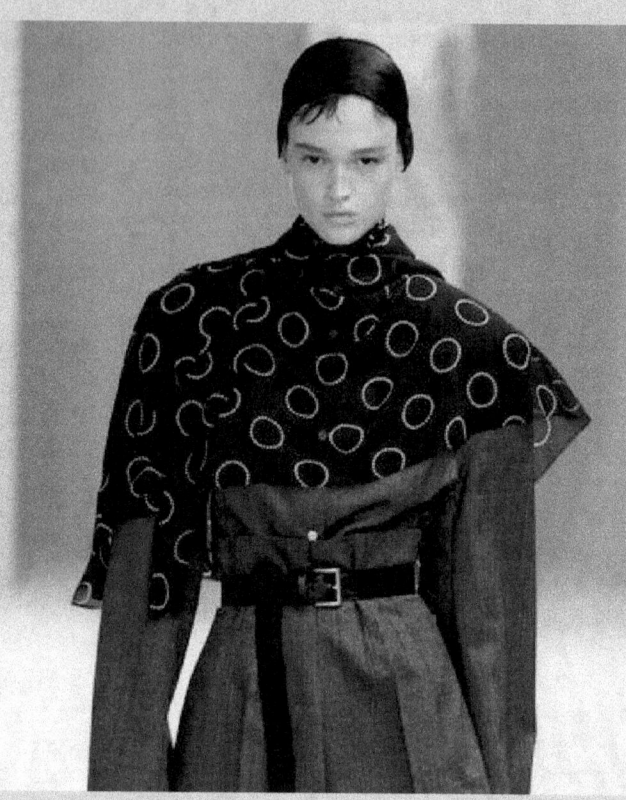

82

Gucci in Space: In 2017, Gucci sent some of its designs into space as part of a project with the Italian space agency, literally symbolizing the brand's ambition to push the boundaries of what is possible.

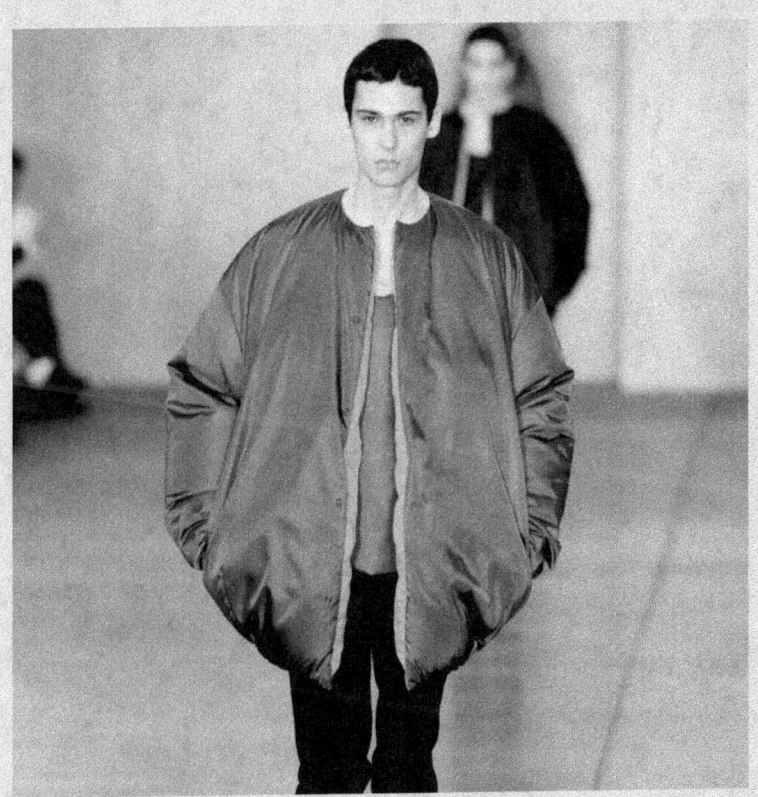

83

Cultural Impact

Prada's revolutionary approach to runway shows has had a significant impact on the fashion industry, raising the standards of what a fashion presentation can and should be. By breaking conventions and constantly pushing the boundaries of creativity, Prada has helped expand the perception of fashion as a form of art and cultural expression, influencing designers and brands around the world.

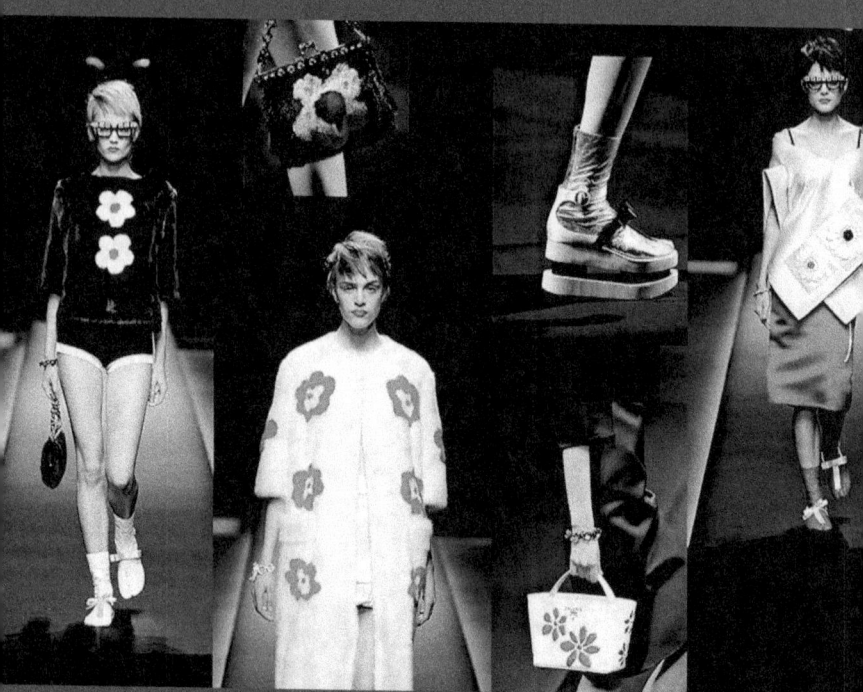

84

Prada fashion shows, with their bold blend of innovation, art and culture, are not only key moments in the fashion calendar; they are cultural events in themselves. Through these groundbreaking presentations, Prada continues to redefine the industry, proving that fashion is a field rich in creative and storytelling possibilities. By transforming its shows into living works of art, Prada doesn't just show clothes; she invites the world to reimagine fashion itself.

85

Feminist Commitment: Under the leadership of Miuccia Prada, the brand has often expressed a commitment to feminism, presenting collections that challenge gender norms and celebrate female empowerment through fashion.

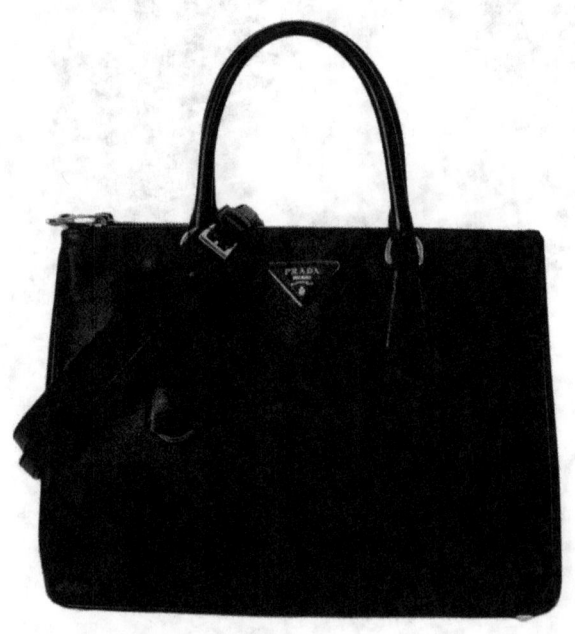

86

Iconic Prada Galleria Bag: Launched in 2007, the Prada Galleria bag has become one of the brand's most iconic and desirable handbags, recognized for its elegant design and functionality, symbolizing Prada's timeless luxury.

87

Collaboration with Contemporary Artists: Prada has frequently collaborated with contemporary artists to create unique works that fuse fashion with art, including installations and specially commissioned artworks for its shows and boutiques.

88

Influence on Interior Design: The brand has extended its influence beyond fashion and accessories by getting involved in interior design, with projects such as creating unique concepts for its boutiques and collaborations with renowned architects and interior designers.

89

Prada and Education: Prada is committed to supporting education through the Prada Foundation, offering programs, workshops and scholarships for young talents in the fields of art, culture and science.

90

Prada Wearable Technology: Beyond the LG Prada phone, the brand has explored the realm of wearable technology with innovative accessories that combine technology and luxury design.

91

Contribution to Italian Heritage: Prada has played a key role in the conservation of Italian cultural heritage, participating in the restoration of historical monuments and supporting projects that enhance Italy's artistic and architectural heritage.

"

The Prada family, at the head of one of the most prestigious fashion houses in the world, has a rich history that is closely intertwined with the evolution of the Prada brand itself. Here are some interesting facts about the members of the Prada family and their impact on the brand

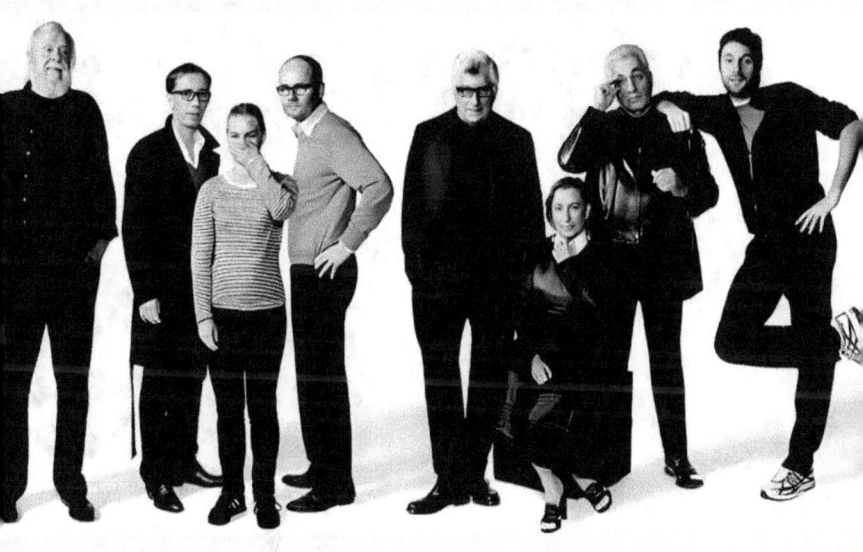

From left to right: artists John Baldessari, Carsten Holler, Nathalie Djurberg and Thomas Demand; Patrizio Bertelli and Miuccia Prada of Prada; commissioner Germano Celant; the artist Francesco Vezzoli.

Credit: Matthias Vriens

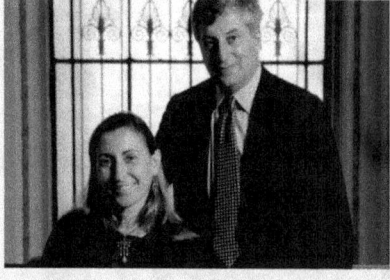
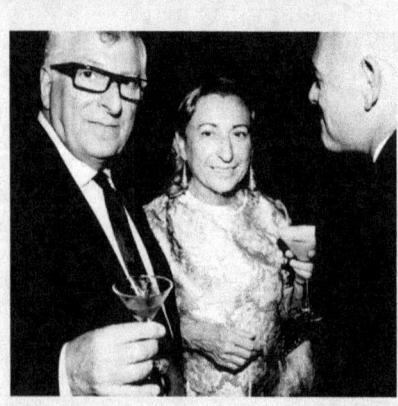

Photoshoot Prada

92

Founded by Mario Prada: Mario Prada, the grandfather of Miuccia Prada, founded Fratelli Prada (Prada Brothers) in 1913 with his brother Martino. The original boutique, located at the prestigious Galleria Vittorio Emanuele II in Milan, sold luxury leather goods, luggage and imported accessories.

93

Miuccia Prada, a visionary: Born in 1949, Miuccia Prada inherited the family business in 1978 and transformed the brand into a world-renowned fashion empire. A graduate in political science, Miuccia also studied mimo-dramaturgy, which influenced her creative and intellectual approach to fashion.

Meeting Patrizio Bertelli: In the 1970s, Miuccia met Patrizio Bertelli, an Italian entrepreneur, who became not only her life partner but also the general director of Prada. Bertelli introduced a corporate structure and international development strategy, playing a key role in Prada's expansion.

Fashion's Power Couple: Together, Miuccia Prada and Patrizio Bertelli form one of the fashion industry's most powerful and influential couples, recognized for their ability to combine creativity, innovation and commercial acumen.

96

Lorenzo Bertelli, the new generation:
Lorenzo Bertelli, the son of Miuccia Prada and Patrizio Bertelli, has joined the family business, bringing a new perspective and continuing the family legacy. Before joining Prada, Lorenzo was known in the world of car rallying, but he gradually became involved in Prada's marketing and digital strategy.

Commitment to art and culture: The Prada family has a deep passion for art and culture, exemplified by the creation of the Prada Foundation in 1993. This cultural institution is dedicated to contemporary art, cinema, and to philosophy, reflecting the family's commitment to cultural patronage.

Influence on the Prada Foundation: Under the leadership of Miuccia and Patrizio, the Prada Foundation has established itself as an influential space for contemporary art, with projects and exhibitions that often challenge conventions and encourage critical thinking.

A brand synonymous with family: Despite its global expansion and commercial success, Prada remains deeply rooted in its family values, with a commitment to quality, craftsmanship and a forward-thinking vision of fashion.

The Prada family continues to influence the direction and identity of the brand, preserving its heritage while constantly pushing the boundaries of innovation in fashion, art and culture.

97

Generational Transition: With Lorenzo Bertelli, son of Miuccia Prada and Patrizio Bertelli, already involved in the Prada group, the future of the brand appears to include a careful generational transition. Lorenzo showed particular interest in digital marketing and sustainability, indicating that these areas could become even more central to Prada in the future.

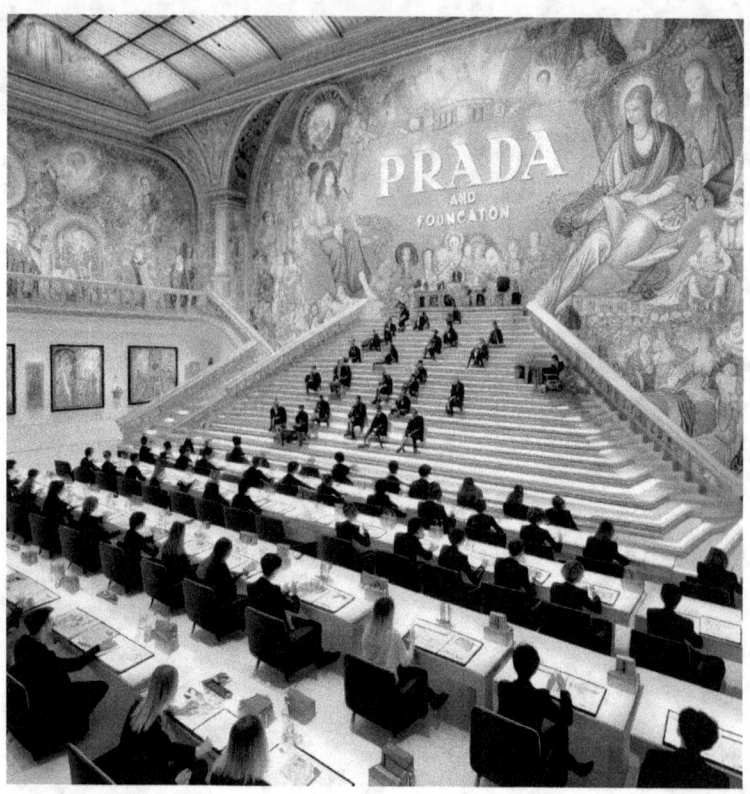

98

Focus on Sustainability: Prada has already made significant commitments to sustainability, and this commitment is likely to deepen. Under the leadership of the next generation, Prada could continue to innovate by using sustainable materials, improving supply chain transparency and adopting business practices that minimize environmental impact.

Product Innovation

Prada has always been at the forefront of innovation in fashion, introducing revolutionary materials, avant-garde designs and innovative manufacturing techniques. Going forward, we can expect Prada to continue experimenting with sustainable and eco-friendly materials, meeting growing consumer demand for responsible products. This could include the increased use of recycled textiles, manufacturing processes with low environmental impact, and the integration of wearable technologies into fashion accessories, combining style and functionality.

Brand Extension:
Beyond fashion and accessories, Prada could explore new avenues in the areas of luxury and lifestyle, such as beauty, hospitality, or even gastronomy, as illustrated by its investment in the Marchesi 1824 patisserie. These brand extensions would allow Prada to offer a more holistic luxury experience, touching different aspects of its customers' lives.

Personalized Services:
The future will likely see Prada strengthen its personalized service offering. This could include personalized style consultations, private shopping experiences, and product customization options, allowing customers to create bespoke pieces that reflect their unique identity. With the advancement of technology, these services could be made available both in-store and online, providing increased convenience and exclusivity.

Unique Customer Experiences:
Prada is well positioned to deliver unique and memorable experiences to its customers, going beyond the simple act of purchasing. This could include invitations to exclusive events, early previews of new collections, interactive workshops with artisans, or immersive experiences in the world of Prada. These initiatives would strengthen the emotional connection between the brand and its customers, creating unforgettable moments.

Prada's future in product and service innovation promises to further expand the brand's horizons. By remaining true to its heritage of innovation while embracing the changes and challenges of the modern era, Prada is poised to continue to captivate and engage its customers in a meaningful and lasting way. The focus on sustainability, the expansion of the brand into new areas of luxury, personalized services and unique experiences for customers demonstrate Prada's dynamic and forward-thinking vision for the future.

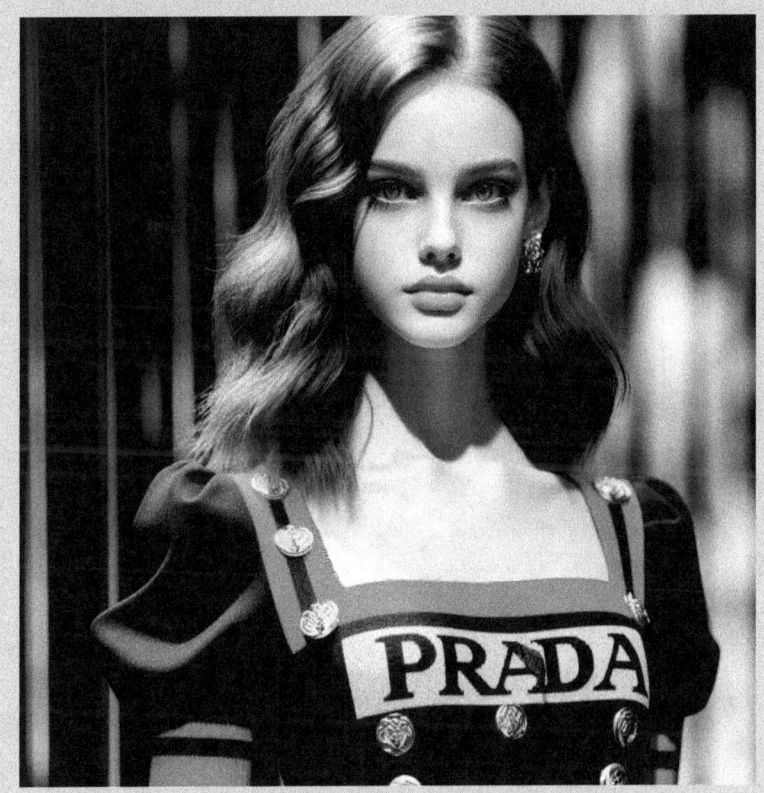

99

Global Growth Strategies: Prada's future could include strategic expansion into new international markets, while strengthening its presence in regions where the brand is already well established. This could involve opening new stores, exploring collaborations with other brands and artists, and participating in global initiatives.

100

Corporate Social Responsibility: Prada is likely to continue to strengthen its corporate social responsibility programs, with a focus on initiatives that support education, gender equality, and community well-being, reflecting thus the deep values of the Prada family.

101

Blockchain for Authenticity: The use of blockchain technology could be expanded to ensure the authenticity of Prada products and improve supply chain traceability. This would help fight counterfeiting while assuring consumers of the quality and ethical origin of their purchases.

102

Adoption of AI in Design: Artificial intelligence (AI) could play an increased role in the design process at Prada, from analyzing fashion trends to personalizing product recommendations for customers, offering thus creations even more adapted to the desires of consumers.

103

Rental and Recycling Programs: Faced with growing demand for more circular fashion, Prada could develop luxury clothing rental programs and recycling/resale initiatives to extend the lifespan of its products, thereby aligning itself with on the principles of the circular economy.

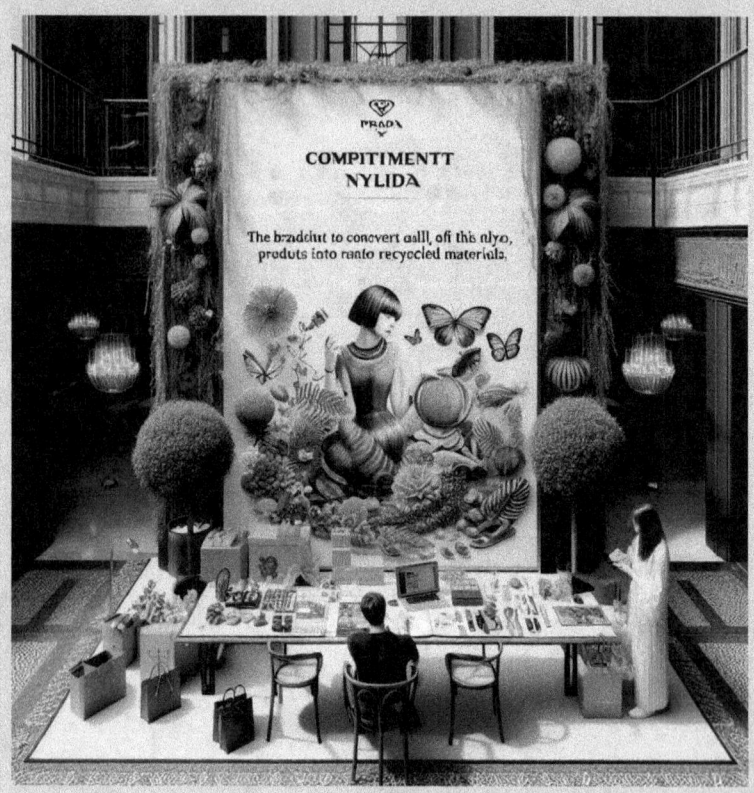

104

In-Store Green Initiatives: Prada could increase the adoption of eco-friendly solutions in its stores, such as the use of sustainable materials in construction and interior design, as well as the implementation of energy saving and waste reduction systems. waste, to promote a greener retail experience.

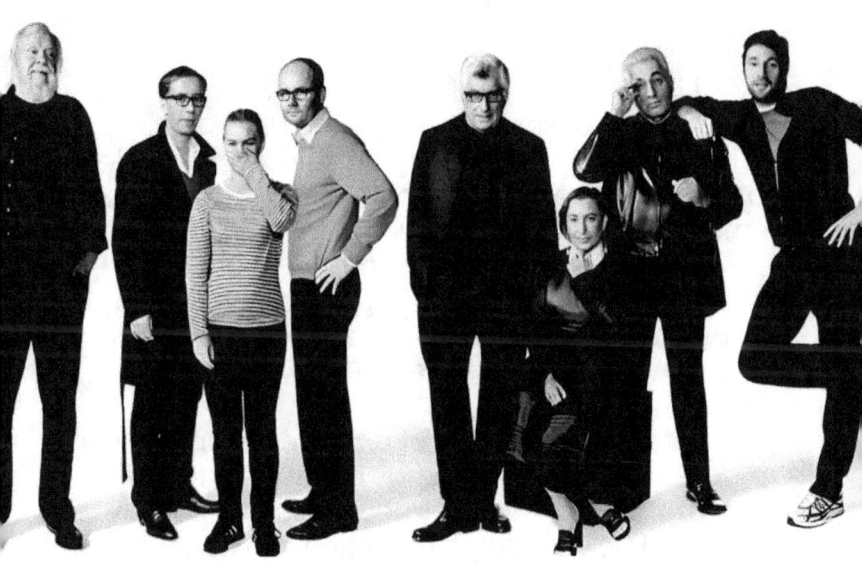

As we turn the final page of our detailed exploration of Prada, we are confronted with a vision of the future that reflects not only the richness and innovation of this iconic brand but also its unwavering commitment to excellence, sustainability and the artistic avant-garde. Prada, under the visionary leadership of the Prada family and its passionate collaborators, promises to continue to push the boundaries of fashion, influence culture and inspire a future where fashion and social responsibility coexist harmoniously.

With a heritage firmly rooted in innovation and respect for artisanal know-how, Prada heads into the future armed with an insatiable curiosity and a desire to contribute positively to our world. The adoption of emerging technologies, commitment to sustainable practices, and initiatives to enrich culture and education all demonstrate Prada's ability to constantly reinvent itself while remaining true to its essence.

The future of Prada, full of promise and innovation, does not just follow trends but aspires to define them, offering unique experiences that celebrate individuality, encourage reflection and honor beauty in all its forms . By embracing the challenges of our time with boldness and creativity, Prada positions itself not only as a leader in the world of luxury fashion but also as a true agent of change, positively influencing the fashion industry and beyond .

Our journey through the history and evolution of Prada leaves us with one certainty: the future of Prada shines brightly, driven by a brand that remains steadfast in its quest for excellence and innovation. Prada continues to be a source of inspiration, proving that fashion can be a powerful vector of progress, beauty and well-being in our world.

PRADA

"What you wear is a way of expressing who you are without having to speak."

Prada

www.ingramcontent.com/pod-product-compliance
Lightning Source LLC
Chambersburg PA
CBHW052321220526
45472CB00001B/217